IMAGES
of Rail

SUBURBAN
PHILADELPHIA TROLLEYS

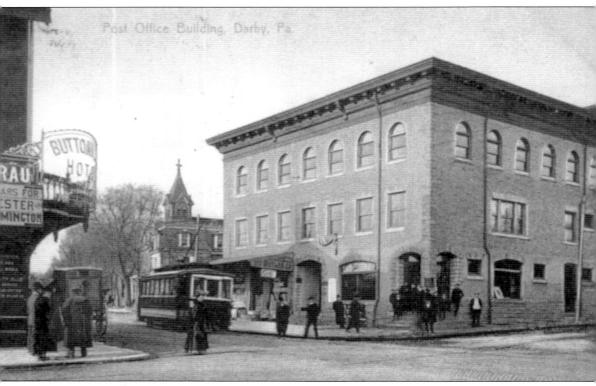

A vintage trolley car is on Main Street at Ninth Street in the borough of Darby in this postcard scene taken about 1910. This was a terminal point for trolley connections to many Pennsylvania and Delaware communities. Although the Buttonwood Hotel (named for nearby buttonwood trees) and the post office building have long since been demolished, route 11 trolleys in 2007 still provide direct trolley car service to downtown Philadelphia.

On the cover: Philadelphia Suburban Transportation Company car No. 22 is at Terminal Square in Upper Darby Township heading for the borough of Media on April 27, 1968. This was the last privately owned transit company still operating trolley cars in the United States and was taken over by the Southeastern Pennsylvania Transportation Authority on January 29, 1970. (Photograph by Kenneth C. Springirth.)

IMAGES
of Rail

SUBURBAN
PHILADELPHIA TROLLEYS

Kenneth C. Springirth

ARCADIA
PUBLISHING

Published by Arcadia Publishing
Charleston SC, Chicago IL, Portsmouth NH, San Francisco CA

Printed in the United States of America

Library of Congress Catalog Card Number: 2007922542

For all general information contact Arcadia Publishing at:
Telephone 843-853-2070
Fax 843-853-0044
E-mail sales@arcadiapublishing.com
For customer service and orders:
Toll-Free 1-888-313-2665

Visit us on the Internet at www.arcadiapublishing.com

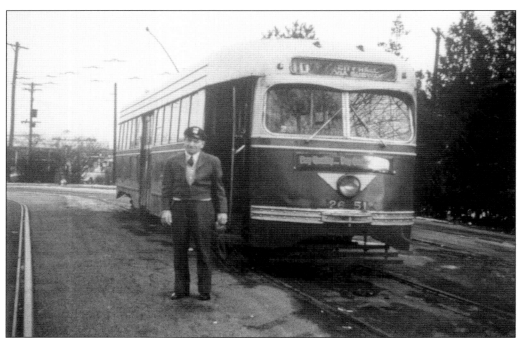

This book is dedicated to the author's father, Clarence E. Springirth, who was a trolley car motorman in Philadelphia and is shown with Presidents' Conference Committee car No. 2651 on Philadelphia Transportation Company route 10 at Sixty-third Street and Malvern Avenue Loop in 1962. This trolley car was built in 1942 by St. Louis Car Company and was scrapped during 1981. (Photograph by Kenneth C. Springirth.)

CONTENTS

ACKNOWLEDGMENTS

James Gillin and Craig Knox began photographing trolleys before graduating from high school in 1960. It was their recognition of the importance of the trolley car that stirred me into joining them as we set out to photograph and learn about the transportation history in Delaware County. All three of us graduated from Lansdowne Aldan High School, which was an excellent public school that taught me the necessary writing skills. My parents, Clarence and Sallie Springirth, provided me an appreciation for public transit and the importance of handling details, which is a necessary part in writing a book. My father was a trolley car motorman in Philadelphia and went to work with his uniform cleaned and pressed, and his shoes always had a military shine. My mother was a very practical resourceful person who would always have dinner ready to meet dad's work schedule. Matthew W. Nawn, who is first vice president, maintenance department cochairman, and project manager for the car No. 355 restoration project at Rockhill Trolley Museum, was a constant source of information. Jean Shiber, chairperson of the Sharon Hill Historical Commission; Richard Paul, treasurer of the Marple Historical Society; Nickie Marquis, reference librarian of the Media Upper Providence Free Library; Sue Eshbach, director of library services at Darby Free Library; Betty Schell, history archives curator of Darby Free Library; and Oliver Ogden of the Museum of Bus Transportation provided information. I wish to thank John and Jan Haigis, co-coordinators of the OC (October) Trolley Fest; Scott Maits, OC transportation consultant; Elizabeth Harris, assistant vice president at Yeadon Office Sovereign Bank; and William Neil, the Yeadon Borough emergency management coordinator, for all of their work in making the OC Trolley Fest possible. *Street Railway Journal, Electric Railway Journal, Electric Railroaders' Association Headlights,* and the *Philadelphia Evening Bulletin* were sources of information for this book. It is important to recognize the father of electric rail transportation, Frank Julian Sprague (born July 25, 1857, died October 25, 1934), who formed the Sprague Electric Railway and Motor Company that completed the first practical trolley system in the United States in Richmond, Virginia, on February 2, 1888.

INTRODUCTION

On August 15, 1895, the Philadelphia and West Chester Traction Company opened a trolley line from Sixty-third Street to Newtown Square using steam dummies purchased from the Frankford and Southwark Passenger Railway Company. On May 6, 1896, electric trolley car service began. Trolley car service to the borough of West Chester began on December 17, 1898. The Ardmore and Llanerch Street Railway constructed a trolley line to Ardmore, which opened on May 29, 1902. The Philadelphia and Garrettford Street Railway completed a new trolley line from the Sixty-ninth Street Terminal to the borough of Clifton Heights on March 15, 1906. This line was extended south with service to the Clifton Aldan station of the Pennsylvania Railroad on April 30, 1907; Providence Road on June 30, 1907; the borough of Collingdale on July 15, 1907; and the borough of Sharon Hill on August 1, 1917. Trolleys began using the new Sixty-ninth Street Terminal on April 30, 1907, followed by the Philadelphia and Western Railway on May 22, 1907. Service to the borough of Media opened on April 1, 1913. Ten new one-man-operated lightweight trolleys, cars numbered 77–86, were obtained from J. G. Brill Car Company during 1932. To handle more bus routes and improve trolley car operations, the Sixty-ninth Street Terminal was rebuilt, and a reopening ceremony was held on October 26, 1936.

The various subsidiaries that built the West Chester, Media, Sharon Hill, and Ardmore trolley lines were merged into the Philadelphia Suburban Transportation Company, and the system became known as the Red Arrow. In 1941, J. G. Brill Car Company provided 10 new lightweight Brilliner cars numbered 1–10. Three Hog Island trolleys (built 1918–1919) that had been used to carry workers to the Hog Island Shipyard were purchased from the Philadelphia Transportation Company during October 1942 to handle the increased ridership during World War II. They were renumbered 20–22 and later became car Nos. 25–27. Delivery of 14 new trolley cars numbered 11–24 from St. Louis Car Company occurred during 1949. The West Chester trolley line was converted to bus operation on June 4, 1954, to avoid the expense of relocating tracks due to the widening of West Chester Pike to four lanes. Rush-hour trolley service continued on the West Gate Hills line until it was abandoned on August 23, 1958.

The Southern Pennsylvania Bus Company, which operated bus routes between Darby, Chester, and Media, had been on strike since March 22, 1960. Red Arrow formed a subsidiary Red Arrow Lines Inc., which purchased the Southern Pennsylvania Bus Company and resumed bus service on June 30, 1960. Red Arrow purchased four Delaware County bus routes from the Philadelphia Transportation Company: 71 Essington–Media, 76 Darby–Chester, 77 Media–Chester, and 82 Morton–Springfield. The Ardmore trolley line made its last run on December 29, 1966. Trackage was retained on West Chester Pike from the Sixty-ninth Street Terminal to the Llanerch carbarn for the surviving Media and Sharon Hill trolley lines.

On May 22, 1907, the Philadelphia and Western Railway completed a grade-separated line from the Sixty-ninth Street Terminal to the community of Strafford. A branch line was built from the community of Villanova to the borough of Norristown, and service from the Sixty-ninth Street Terminal to Norristown began on August 26, 1912. Lehigh Valley Transit

Company began through service from the Sixty-ninth Street Terminal to Allentown on December 12, 1912. Ten new high-speed aerodynamically designed Bullet cars built by J. G. Brill Car Company numbered 200–209 were placed in service during 1931. On September 26, 1949, Lehigh Valley Transit cars were cut back to Norristown, and riders transferred to Philadelphia and Western Railway cars to the Sixty-ninth Street Terminal. The Philadelphia and Western Railway became part of the Philadelphia Suburban Transportation Company on December 31, 1953. Declining ridership resulted in the abandonment of the Strafford line from Villanova Junction to Strafford on March 23, 1956.

On April 3, 1893, the Chester and Media Electric Railway Company opened a trolley line from the city of Chester to the borough of Media. The Chester, Darby, and Philadelphia Electric Railway connected Chester with Darby on December 7, 1893. Electrified trolley service from Philadelphia to Darby began on May 29, 1894, by the Philadelphia Traction Company, which later became Philadelphia Rapid Transit Company route 11. The Delaware County and Philadelphia Electric Railway Company completed a trolley line along Baltimore Pike from the Angora section of Philadelphia to Media in 1894. This became part of the Southern Pennsylvania Traction Company on July 1, 1910. In August 1895, the Prospect Park Street Railway Company opened a trolley line from the borough of Prospect Park via Lincoln Avenue, Lazaretto Road, and Wanamaker Avenue to Tinicum Township, which later became route 72 of the Philadelphia Rapid Transit Company. This line was abandoned on August 14, 1938, and a Folsom Shuttle trolley operated through Ridley Township from Lincoln Avenue and the Baltimore and Ohio Railroad via Lincoln Avenue to Melrose Terrance and Linden Avenue until its last day of operation on July 29, 1939. Trolley service from Darby to Chester via Chester Pike became Philadelphia Rapid Transit Company route 76. During January 1904, this line was extended via private right-of-way from Chester Pike and Parker Avenue to Ninth and Main Streets in Darby. On September 11, 1932, route 76 was converted to bus operation between the Folsom section of Ridley Township and Darby, and rail service continued between Folsom and Chester until replacement by bus on May 26, 1935. In 1903, the Media, Glen Riddle, and Rockdale Electric Street Railway Company opened a trolley line from Media to the community of Glen Riddle. It became part of the Southern Pennsylvania Traction Company in 1910. On July 4, 1904, the Philadelphia, Morton, and Swarthmore Street Railway Company completed a line from Darby via Swarthmore to Media; it was later leased to the Philadelphia Rapid Transit Company and became route 71. On June 6, 1932, route 71 was discontinued between Folsom and Darby and only operated between Media and Folsom until August 14, 1938, when it was replaced by the Essington–Media bus line.

The Media, Middletown, Aston, and Chester Electric Railway completed a trolley line from Chester via Edgmont Avenue and Middletown Township to Olive Street terminating at Fifth Street in Media on April 1, 1905. It was later leased to the Philadelphia Rapid Transit Company and became route 77 with conversion to bus operation on April 5, 1936. On July 4, 1902, the Media, Middletown, Aston, and Chester Electric Railway opened a line from the borough of Darby to the borough of Lansdowne using Ninth Street eastbound (Tenth Street westbound), Summit Street, Eleventh Street, Union Avenue, and Wycombe Avenue to Fairview Avenue, which later became Philadelphia Rapid Transit Company route 78 with conversion to bus operation on June 22, 1947. On May 1, 1902, the Philadelphia Rapid Transit Company emerged from a consolidation of 33 trolley companies. The Southern Pennsylvania Traction Company began converting trolley lines to bus operation with abandonment of the Chester–Media line on April 12, 1930; Media–Angora line on August 2, 1930; Media–Glen Riddle line on August 2, 1930; and Darby–Chester line on December 15, 1934.

Three lines connected Delaware County with downtown Philadelphia via the subway: route 11 Darby, route 13 Yeadon, and route 37 Chester. Route 11 used Woodland Avenue to reach Market Street in Philadelphia and was rerouted into the new downtown subway on December 15, 1906. From April 15, 1901, to November 6, 1955, route 12 connected Darby to Philadelphia via Woodland and Grays Ferry Avenues. On June 1, 1907, the Darby and Yeadon Street Railway

Company, which later became the Philadelphia Rapid Transit Company, opened an extension of the route 13 Chester Avenue line from Darby to Sixty-fifth Street and Kingsessing Avenue via Ninth Street eastbound (Tenth Street westbound), Cedar Avenue, and Chester Avenue. Beginning on May 25, 1913, route 13 operated from Darby to Front and Chestnut Streets in Philadelphia. Effective November 10, 1918, route 62 was established to operate from Darby to Mount Moriah Loop in Philadelphia where riders transferred to route 13 for Center City Philadelphia. On June 19, 1927, route 13 operated into a new loop in the borough of Yeadon at Chester Avenue and Callahan Street. Route 62 now operated from Darby to Yeadon Loop.

By 1899, the Southwestern Traction Company completed a line from Philadelphia through southern Delaware County to Chester. This line was purchased by the Philadelphia Rapid Transit Company and was upgraded becoming route 37. On January 1, 1940, the Philadelphia Rapid Transit Company reorganized as the Philadelphia Transportation Company. On October 30, 1944, a new loop was placed in operation at the Westinghouse plant, and on December 10, 1944, a new loop was placed in operation at Ninety-fourth Street. Route 37 was cut back from Chester to the community of Lester on November 24, 1946. On November 6, 1955, route 37 was combined with route 36 and continued to operate to Lester until September 9, 1956, when it was cut back to Ninety-fourth Street just inside the Philadelphia city limits.

National City Lines acquired the Philadelphia Transportation Company in 1955, and many trolley routes were converted to bus operation. Subway surface tunnels were extended to Thirty-sixth and Ludlow Streets for route 10 and Fortieth Street and Woodland Avenue for routes 11, 13, 34, and 36. The first eastbound trolley car No. 2631 went through the new subway on October 17, 1955, and the first westbound trolley car No. 2628 went through the subway on November 7, 1955. The Market Street Subway was extended to Forty-third and Market Streets where the line climbed back on the elevated structure with the new service beginning on October 31, 1955. Route 13 began using the new subway on September 9, 1956. On Sunday, August 11, 1957, trolley route 41 was abandoned with Presidents' Conference Committee car No. 2674 leaving Sixty-third and Market Streets at 1:38 a.m. On January 16, 1911, this line operated on Market Street from Front Street to Sixty-ninth Street replacing the Philadelphia and West Chester Traction Company between Sixty-third Street and Sixty-ninth Street when the Sixth-ninth Street Terminal opened. On October 9, 1921, route 41 operated from Sixty-third Street and Lancaster Avenue to Sixty-third and Market Streets and to Front and Market Streets. Effective September 12, 1926, route 41 operated from Sixty-third Street and Lancaster Avenue via Sixty-third Street to Sixty-third and Market Streets.

The Southeastern Pennsylvania Transportation Authority took over the Philadelphia Transportation Company on September 30, 1968, and the Philadelphia Suburban Transportation Company on January 29, 1970. Route 62 Darby–Yeadon shuttle was discontinued, and service was provided by through routing a number of route 13 trolleys on January 23, 1971. On November 29, 1971, the Llanerch carbarn was closed, and the Media and Sharon Hill lines operated out of the Sixty-ninth Street shops.

Merchants of the borough of Media conducted an annual sidewalk sale that incorporated the trolley line on State Street in downtown Media. When it was learned that $900 was needed to have trolley car No. 73 at the fair, the Media Office Supply and the Media Area Jaycees guaranteed trolley costs for the event to be held on July 28, 29, and 30, 1977. The cost to ride the trolley was 10¢ (free to senior citizens over 65).

During 1981, Kawasaki Heavy Industries of Kobe, Japan, built 112 single-end trolley cars numbered 9000–9111 for the subway surface trolley lines and 29 double-end trolley cars numbered 100–128 for the Media and Sharon Hill trolley lines. On November 20, 1981, the new Elmwood Depot went into service. At the site of the former Woodland Depot, new Woodland workshops were officially dedicated on June 25, 1984. During 1990 to 1994, Asea Brown Boveri built 26 double-end cars numbered 130–155 for the Norristown line.

A community celebration of transportation heritage took place on October 15, 2005. This was the first OC (October) Trolley Fest, and the second annual OC Trolley Fest occurred

on October 14, 2006. Free trolley rides were conducted aboard two rebuilt 1947 Presidents' Conference Committee trolleys on a routing through the suburban communities of Darby, Yeadon, and Colwyn to southwest Philadelphia that developed because of the direct trolley car service to Philadelphia. The trolleys were from the group of 18 Presidents' Conference Committee cars originally built by St. Louis Car Company during 1947–1948 and were completely rebuilt by Brookville Equipment Corporation during 2003–2004 and renumbered 2320–2337 for use on route 15 Girard Avenue. The tour featured the Darby Free Library located at 1001 Main Street (Tenth and Main Streets) served by trolley route 13. The Darby Library Company was formed in 1743 with 29 local residents each contributing a membership fee of 20 shillings ($296.40 in United States dollars for the year 2006), which went for the purchase of books. Members then paid five shillings for annual membership ($74.10 in United States dollars for the year 2006). On November 5, 1743, the shipment of books arrived from England. As noted in a research paper by Sue Eshbach, director of library services, "The Darby Library Company is still providing service to its founding community, making it the oldest continually operating public library in the United States." At the library Betty Schell, history archive curator, has created an excellent display of Darby transportation history and has spent countless hours preserving Darby history at the library. The library has preserved the history of John M. Drew, who was in the retail ice business and noted that many women riders of the Darby to Lansdowne trolley line worked in homes north of the trolley line terminus at Wycombe and Fairview Avenues. He purchased a five-passenger Ford touring car and obtained the right to operate a bus from Darby's Main Street terminal via Main Street and Lansdowne Avenue to Baltimore Pike in Lansdowne. Approval was later received to extend service to the Sixty-ninth Street Terminal using 30-seat buses. Drew sold the bus line to Aronimink Transportation Company, which later became Red Arrow (Philadelphia Suburban Transportation Company) with the agreement that any of his employees, who desired, could have a job with the new owner. This became bus route M (the Sixty-ninth Street Terminal to Darby) and in 2007 is Southeastern Pennsylvania Transportation Authority bus route 113 (the Sixty-ninth Street Terminal via Darby to Marcus Hook). Another important point on the tour is the route 11 trolley grade crossing of the CSX Railroad on Main Street in Darby that is the only remaining trolley line crossing a main line railroad at street grade in the United States.

One

Philadelphia Suburban Transportation Company

The Philadelphia and West Chester Traction Company was incorporated on April 24, 1895, to build a 10.5-mile trolley line from Sixty-third Street in Philadelphia to the community of Newtown Square. Trolley service from the Sixty-ninth Street Terminal to the community of Ardmore began on May 29, 1902. On March 15, 1906, trolley service began from the Sixty-ninth Street Terminal to the borough of Clifton Heights and was extended south to the borough of Sharon Hill by August 1, 1917. Trackage between Sixty-third and Market Streets to Sixty-ninth Street was used by the suburban trolley cars from 1896 until the Sixty-ninth Street Terminal opened in 1907. A shuttle car then operated between Sixty-third Street and Sixty-ninth Street until January 16, 1911, when the Philadelphia Rapid Transit Company operated trolley route 41 from Front and Market Streets to Sixty-ninth and Market Streets. On September 21, 1920, route 41 was cut back to Sixty-third Street, but freight and milk cars continued to use the line until January 27, 1925. Trolley service to the borough of Media began on April 1, 1913. The Aronimink Transportation Company, incorporated on April 4, 1923, as a subsidiary of the trolley company, began bus route A from Sixty-ninth Street to the village of Aronimink on December 1, 1923, and replaced Southern Pennsylvania Traction Company trolleys with bus route N (Angora to Media) on August 4, 1930. On March 31, 1936, the Public Service Commission approved the merger of the Philadelphia and West Chester Traction Company and Philadelphia and Garrettford Street Railway into the Philadelphia Suburban Transportation Company. Aronimink Transportation Company merged into the system on December 31, 1941. A new emblem was designed, and the system became known as the Red Arrow. Buses replaced trolleys on the West Chester line on June 4, 1954, the West Gate Hills line on August 23, 1958, and the Ardmore line on December 30, 1966. Media and Sharon Hill trolley lines remained along with the Norristown line of the former Philadelphia and Western Railway Company. Three generations of the Taylor family (A. Merritt Taylor, Merritt H. Taylor, and Merritt H. Taylor Jr.) created a well-run profitable transit company.

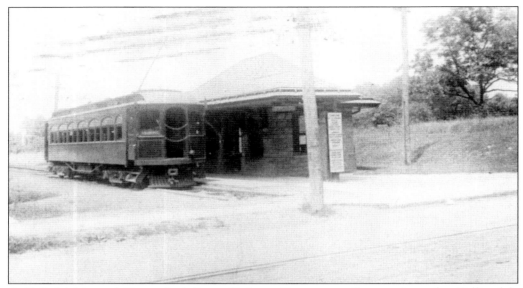

A Philadelphia and Garrettford Street Railway Company trolley car is at the Collingdale terminus in 1908 awaiting departure time for the trip to the Sixty-ninth Street Terminal. The track in the lower portion of the postcard is on Mac Dade Boulevard. This was a transfer point for Philadelphia Rapid Transit trolleys westbound to Folsom and eastbound to the borough of Darby.

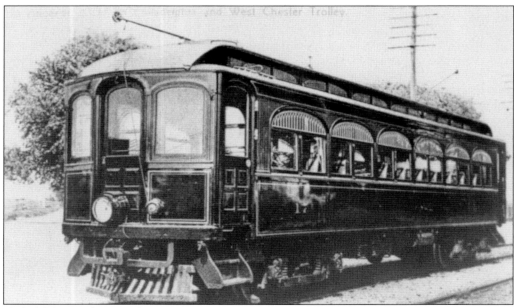

Philadelphia and West Chester Traction Company car No. 17 is basking in the sunlight on West Chester Pike around 1910. J. G. Brill Car Company built this car in 1906 as part of an order for seven cars numbered 17–23. The 45.3-foot-long car weighed 68,000 pounds, seated 48, and was powered by four General Electric model 73 motors.

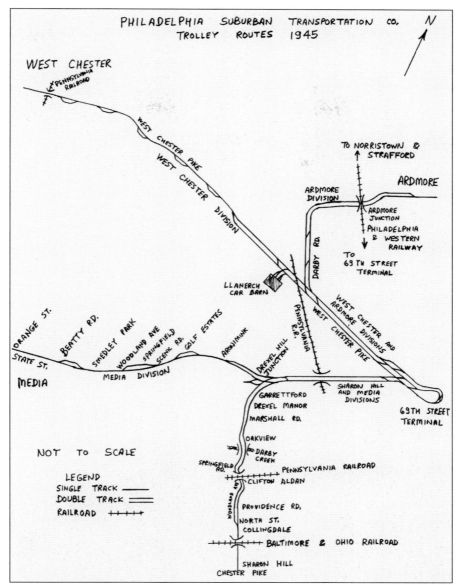

PHILADELPHIA SUBURBAN TRANSPORTATION CO.
TROLLEY ROUTES 1945

N

WEST CHESTER

PENNSYLVANIA RAILROAD

WEST CHESTER PIKE

WEST CHESTER DIVISION

TO NORRISTOWN &
STRAFFORD

ARDMORE

ARDMORE DIVISION

ARDMORE JUNCTION

PHILADELPHIA & WESTERN RAILWAY

TO 69 TH STREET TERMINAL

DARBY RD.

LLANERCH CAR BARN

PENNSYLVANIA R.R.

WEST CHESTER AND ARDMORE DIVISIONS

WEST CHESTER PIKE

ORANGE ST.

STATE ST.

BEATTY RD.

SMEDLEY PARK

WOODLAND AVE

SPRINGFIELD RD.

SCENIC RD.

GOLF ESTATES

AROMIMINK

DREXEL HILL JUNCTION

MEDIA

MEDIA DIVISION

SHARON HILL AND MEDIA DIVISIONS

69TH STREET TERMINAL

GARRETTFORD
DREXEL MANOR
MARSHALL RD.

OAKVIEW

DARBY CREEK

SPRINGFIELD RD.

PENNSYLVANIA RAILROAD

CLIFTON ALDAN

WOODLAND AVE

PROVIDENCE RD.

NORTH ST.
COLLINGDALE

NOT TO SCALE

LEGEND
SINGLE TRACK ——
DOUBLE TRACK ═══
RAILROAD ++++

BALTIMORE & OHIO RAILROAD

SHARON HILL
CHESTER PIKE

Four Philadelphia Suburban Transportation Company trolley routes fanned out from the Sixty-ninth Street Terminal serving Delaware County. The West Chester line was converted to bus operation on June 4, 1954. Regular trolley service to Westgate Hills ended on August 22, 1958. Buses replaced Ardmore trolleys on December 30, 1966. The surviving Media and Sharon Hill trolley lines share common trackage from the Sixty-ninth Street Terminal to Drexel Hill Junction. At Drexel Hill Junction, the Sharon Hill line heads south crossing Darby Creek in the Oakview section of Upper Darby Township. The line leaves the private right-of-way for Springfield Road turning onto Woodland Avenue, and at North Street in the borough of Aldan it becomes single track on private right-of-way ending at Chester Pike in the borough of Sharon Hill. From Drexel Hill Junction the Media line is now double track to Woodland Avenue where it becomes single track to Pine Ridge and goes to double track until Bowling Green, reverting to single track on State Street in the borough of Media ending at Orange Street.

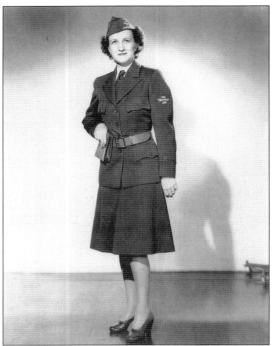

The shortage of manpower during World War II affected virtually all transit companies, including the Philadelphia Suburban Transportation Company, which met this challenge by hiring women to take the place of men serving their country in this great time of need, as noted in this official picture taken by the company. (Matthew W. Nawn collection.)

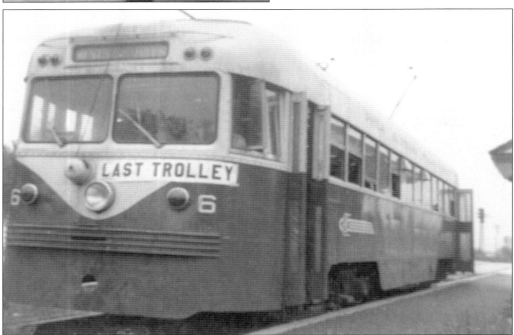

Philadelphia Suburban Transportation Company car No. 6 is at the Westgate Hills station on West Chester Pike for the last excursion run on Sunday August 24, 1958. Regular service ended with the same car on Friday, August 22, 1958. When the West Chester line was converted to bus operation on June 4, 1954, this segment continued to operate only during peak periods. (Photograph by Kenneth C. Springirth.)

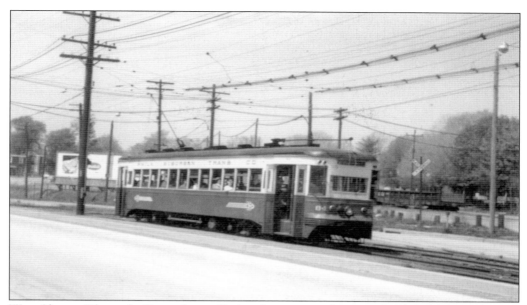

West Chester Pike at the Pennsylvania Railroad crossing is the scene for Philadelphia Suburban Transportation Company car No. 84 on April 24, 1960. Built by J. G. Brill Car Company during 1932, this car seated 61, weighed 41,980 pounds, and had Brill model 89E1 trucks and four General Electric model 301B motors. (Photograph by Kenneth C. Springirth.)

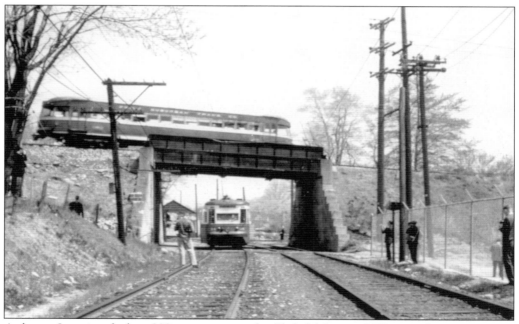

Ardmore Junction finds a 200 series car on the Philadelphia and Western division crossing over the Ardmore trolley line where car No. 84 has paused for a picture stop on April 24, 1960. When the Ardmore trolley line was converted to bus operation on December 30, 1966, a busway was built over this portion of the line and placed in service on March 3, 1967. (Photograph by Kenneth C. Springirth.)

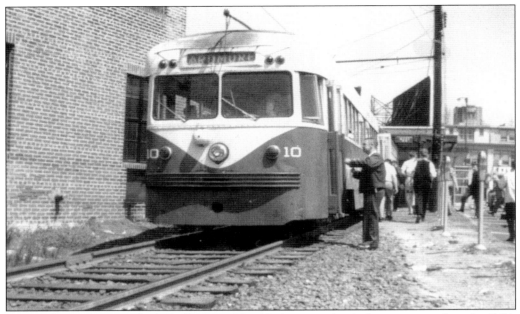

J. G. Brill Car Company built Brilliner car No. 10, shown at the Ardmore terminal on April 24, 1960. This car was destroyed in a wreck on July 30, 1963, leaving nine cars numbered 1–9. These cars weighed 42,350 pounds, seated 58, and had four Westinghouse model 1433 motors. Before the end of 1982, this series of cars was replaced by new Kawasaki Heavy Industries cars. (Photograph by Kenneth C. Springirth.)

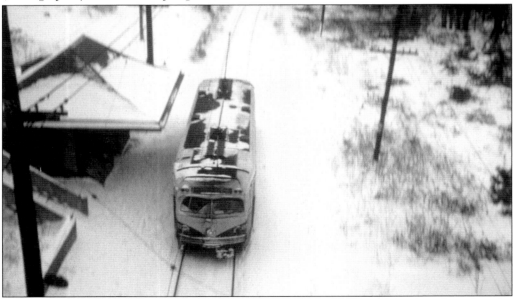

Philadelphia Suburban Transportation Company car No. 20 is at Sproul Road eastbound to the Sixth-ninth Street Terminal on a snowy December 12, 1960. Even with the expansion of nearby highways, the Media line has been a valuable transportation artery that received continuing improvement by Philadelphia Suburban Transportation Company and in recent years by the Southeastern Pennsylvania Transportation Authority. (Photograph by Kenneth C. Springirth.)

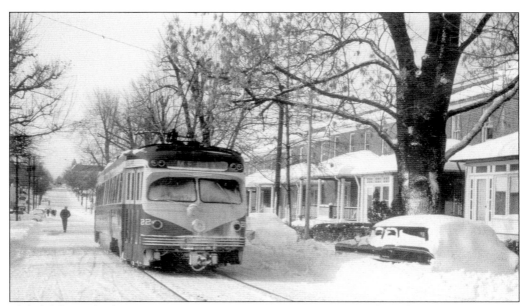

Philadelphia Suburban Transportation Company car No. 22 is westbound on State Street just west of Providence Road in the borough of Media on December 12, 1960. This was one of 14 cars built by St. Louis Car Company and represented the newest cars on the system at that time. These cars weighed 49,000 pounds, seated 58, and had four Westinghouse model 1433 motors. (Photograph by Kenneth C. Springirth.)

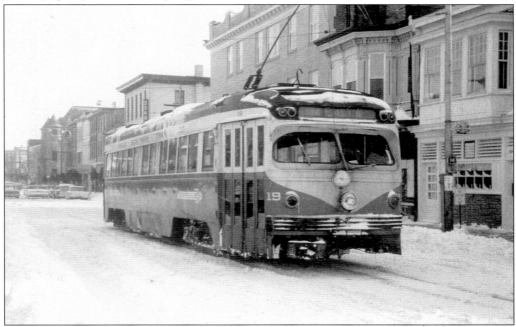

A snowy December 12, 1960, finds Philadelphia Suburban Transportation Company car No. 19 at the end of the line on State Street at Orange Street in the borough of Media awaiting departure time for the eastbound trip to the Sixty-ninth Street Terminal. This St. Louis Car Company product was equipped for multiple-unit operation. (Photograph by Kenneth C. Springirth.)

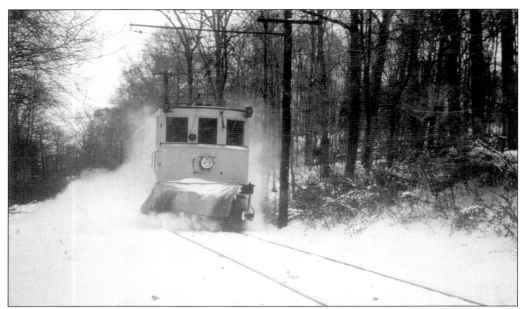

Whirling brushes on Philadelphia Suburban Transportation Company snow sweeper car No. 4 clear the track on the Media line through Smedley Park on December 12, 1960. McGuire Cummings Company built this double-truck snow sweeper in 1922. Most of the Media line is on a traffic-free private right-of-way that has made this an attractive transportation alternative. (Photograph by Kenneth C. Springirth.)

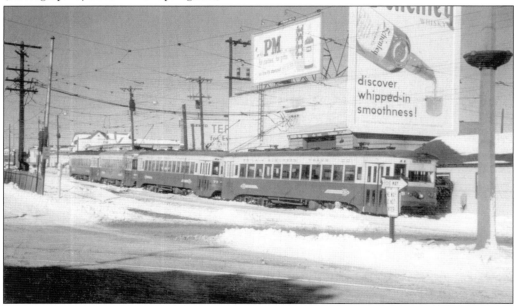

Four lightweight J. G. Brill Car Company cars, including car Nos. 77 and 79, are lined up on the siding at West Chester Pike near the Sixty-ninth Street Terminal on December 13, 1960. These one-man-operated cars, placed in service during 1932, helped the Philadelphia Suburban Transportation Company weather the hard economic times of the 1930s with faster operating speeds, reduced labor costs, and lower power costs. (Photograph by Kenneth C. Springirth.)

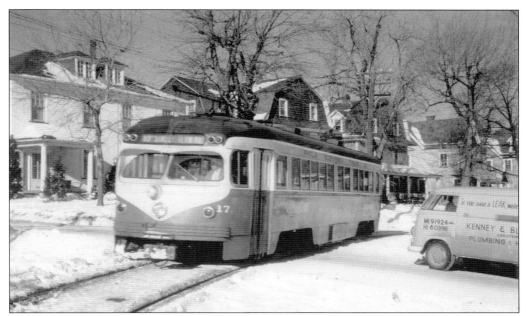

Amid snow-covered County Line Road on January 29, 1961, Philadelphia Suburban Transportation Company car No. 17 is heading for the Sixty-ninth Street Terminal on the Ardmore line. Built by St. Louis Car Company in 1949, the streamline car body was similar to a Presidents' Conference Committee car mounted on high-speed suburban trucks. (Photograph by Kenneth C. Springirth.)

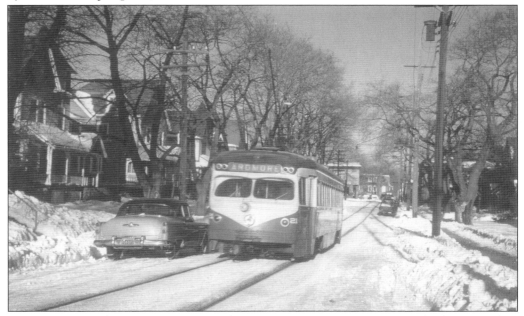

Northbound in the community of Ardmore on January 29, 1961, Philadelphia Suburban Transportation Company car No. 21 is on a route that is an example of the classic small-town trolley line with single-track operation through a picturesque residential neighborhood. Most of the 5.3-mile Ardmore trolley line was double tracked. (Photograph by Kenneth C. Springirth.)

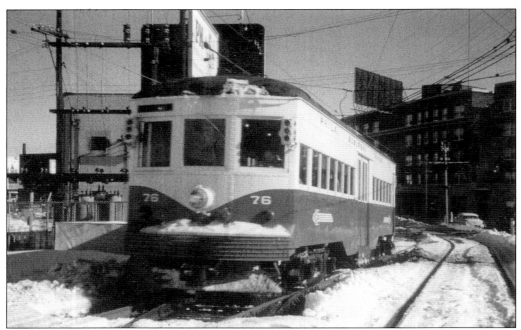

Philadelphia Suburban Transportation Company car No. 76 is on West Chester Pike near the Sixty-ninth Street Terminal on February 5, 1961, on the Ardmore line. The heavy snow resulted in using the vintage center door trolleys on the Ardmore, Sharon Hill, and Media lines to plow through snowdrifts to open each line. (Photograph by Kenneth C. Springirth.)

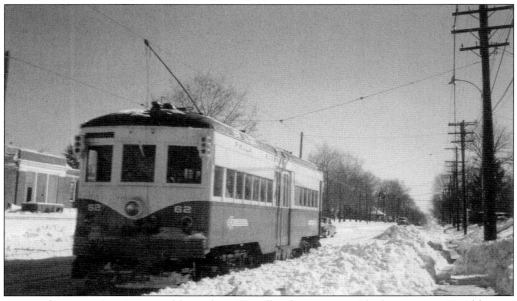

Center door car No. 62 is southbound on Woodland Avenue at Shisler Avenue in Aldan on February 5, 1961, heading for the borough of Sharon Hill. Normally the center door cars were used in school service, but the Philadelphia Suburban Transportation Company assigned these heavy cars to clear the snow-covered track. This car is preserved at the Seashore Trolley Museum at Kennebunkport, Maine. (Photograph by Kenneth C. Springirth.)

This is the weekday Philadelphia Suburban Transportation Company timetable for the West Chester Division from the Sixty-ninth Street Terminal in suburban Philadelphia to the borough of West Chester effective January 8, 1954. Weekday service to West Chester was every 30 minutes, and late evening service was hourly. At certain times weekend service to West Chester was every 15 minutes.

WEEKDAYS (Except Saturday)

WESTBOUND												EASTBOUND										
69th Street Terminal	Highland Park	Llanerch	Eagle Rd.	Westgate Hills	Broomall	Larchmont	Newtown Square	Edgemont	Milltown	West Chester	West Chester	Milltown	Edgemont	Newtown Square	Larchmont	Broomall	Westgate Hills	Eagle Rd.	Llanerch	Highland Park	69th Street Terminal	

West Chester Division transfer of Philadelphia Suburban Transportation Company could be used on Ardmore trolley cars going north at Darby Road, Ardmore–Darby bus going north or south at Darby Road, Bon Air–Ardmore bus going north or south at Eagle Road, and Sixty-third Street Woodland bus going east from the Sixty-ninth Street Terminal. (Oliver Ogden, Museum of Bus Transportation.)

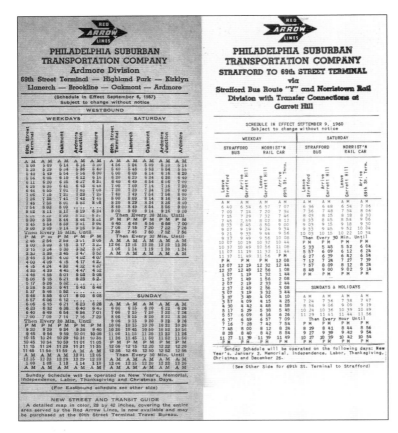

The September 6, 1957, Ardmore Division trolley schedule from the Sixty-ninth Street Terminal to Ardmore shows 67 weekday trips, 53 Saturday trips, and 33 Sunday trips. This line was converted to bus operation on December 30, 1966. With the abandonment of the Strafford line on March 23, 1956, bus service was substituted from Strafford to Garrett Hill, and the September 9, 1960, schedule shows the connection.

A.M. 1	2	3	4	5	6	7	8	9	10	11	12

ARONIMINK TRANSPORTATION COMPANY

ARDMORE–DARBY DIVISION (H)
TRANSFER TICKET 555501

This Transfer Ticket Receivable ONLY—on Route in direction and at junction point as designated on reverse side of this ticket—for a continuous trip in a forward direction of person to whom issued, on date of issuance and within time limit punched.

President

P.M.	2	3	4	5	6	7	8	9	10	11	A.M. 12

This transfer could be used on the Media and Sharon Hill trolleys at Garrett Road, the West Chester trolley at West Chester Pike, the eastbound Ardmore trolley at West Chester Pike, and a number of intersecting bus routes. Aronimink Transportation Company was incorporated on April 4, 1923, as a subsidiary of the Philadelphia Suburban Transportation Company. (Oliver Ogden, Museum of Bus Transportation.)

PHILADELPHIA SUBURBAN TRANSPORTATION COMPANY
Media Division
69th Street Terminal — Bywood — Drexel Hill
Aronimink — Drexelbrook — Springfield — Media

(Schedule in Effect September 6, 1957
Subject to change without notice)

PHILADELPHIA SUBURBAN TRANSPORTATION COMPANY
Sharon Hill Division
69th St. Terminal — Bywood — Drexel Hill — Clifton
Heights — Aldan — Collingdale — Sharon Hill

(Schedule in Effect September 6, 1957
Subject to change without notice)

SOUTHBOUND (Media Division)

69th Street Terminal	Drexel Hill	Drexelbrook	Woodland Avenue Springfield	Media

(Weekday, Saturday, and Sunday schedule columns with times — AM/PM service at frequent intervals; "Then Every 15 Min. Until", "Then Every 20 Min. Until", "The Every 30 Min. Until" noted)

SOUTHBOUND (Sharon Hill Division)

69th Street Terminal	Drexel Hill	Baltimore Avenue	North Street	Sharon Hill

(Weekday, Saturday, and Sunday schedule columns with times)

Sunday Schedule will be operated on New Year's, Memorial, Independence, Labor, Thanksgiving and Christmas Days.

(For Northbound schedule see other side)

(For Northbound schedule see other side)

NEW STREET AND TRANSIT GUIDE
A detailed map in color, 28 by 42 inches, covering the entire area served by the Red Arrow Lines, is now available and may be purchased at the 69th Street Terminal Travel Bureau.

With increased automobile usage, new suburban malls, and a decline in the number of people working in Center City Philadelphia over the last 50 years, ridership has declined. The September 6, 1957, schedule for the Media Division shows from the Sixty-ninth Street Terminal to Media there were 71 trips weekdays, 66 trips on Saturday, and 36 trips on Sunday, while the February 13, 2006, schedule had 48 trips on weekdays, 34 trips on Saturday, and 32 trips on Sunday. The September 6, 1957, schedule for the Sharon Hill Division shows from the Sixty-ninth Street Terminal to Sharon Hill there were 73 trips on weekdays, 68 trips on Saturday, and 38 trips on Sunday, while the February 13, 2006, schedule had 47 trips on weekdays, 38 trips on Saturday, and 32 trips on Sunday. It should be noted that Philadelphia Suburban Transportation Company adequately maintained both lines, and under the Southeastern Pennsylvania Transportation Authority additional improvements have been made.

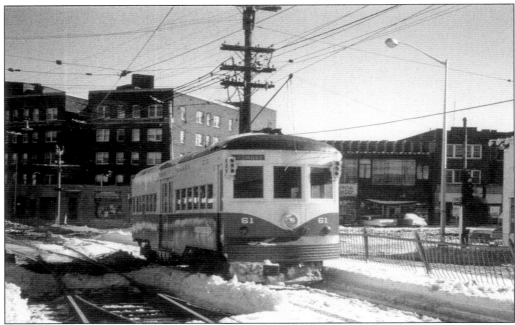

Philadelphia Suburban Transportation Company center door car No. 61 is coming into the Sixty-ninth Street Terminal on the Ardmore line on February 5, 1961. Seating 62 and powered by four General Electric motors model 203L, this car was part of an order for 10 cars numbered 55–64 built by J. G. Brill Car Company in 1925. (Photograph by Kenneth C. Springirth.)

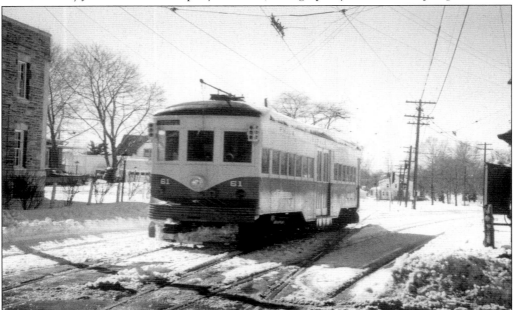

Drexel Hill Junction finds center door car No. 61 heading eastbound from the borough of Media to the Sixty-ninth Street Terminal on February 5, 1961. This massive trolley weighing 59,280 pounds with 33-inch-diameter wheels was 47.83 feet long and 8.58 feet wide. The car is now at the Rockhill Trolley Museum at Rockhill Furnace. (Photograph by Kenneth C. Springirth.)

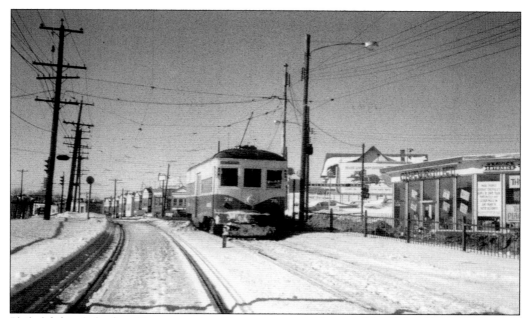

Philadelphia Suburban Transportation Company center door car No. 76 has just pulled out of the Sixty-ninth Street Terminal and is on West Chester Pike on the Ardmore line on February 5, 1961. A number of these cars were retained for school trips and winter snow operation. This car has been preserved at the Electric City Trolley Museum in Scranton. (Photograph by Kenneth C. Springirth.)

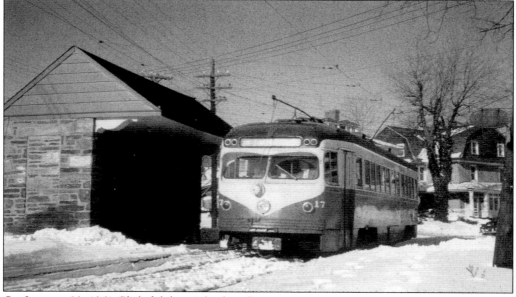

On January 29, 1961, Philadelphia Suburban Transportation Company car No. 17 is at County Line Road on the Ardmore line heading for the Sixty-ninth Street Terminal. These 1949 St. Louis Car Company trolleys were well maintained and provided reliable transit service. The Ardmore trolley line was a major factor in transforming agricultural Haverford Township into a thriving residential community. (Photograph by Kenneth C. Springirth.)

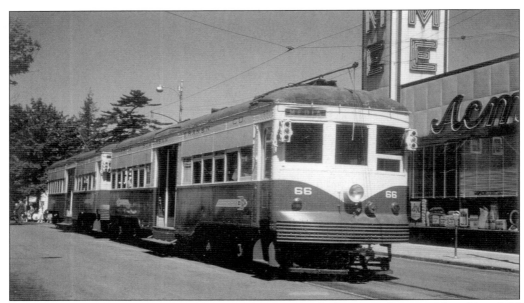

State Street at Orange Street in the borough of Media finds center door car Nos. 66 and 76 on a June 4, 1961, rail excursion. J. G. Brill Car Company built both cars in 1926. Car No. 76 is preserved at the Electric City Trolley Museum at Scranton. Car No. 66 was acquired by the Pennsylvania Trolley Museum at Washington, Pennsylvania, during 1970. (Photograph by Kenneth C. Springirth.)

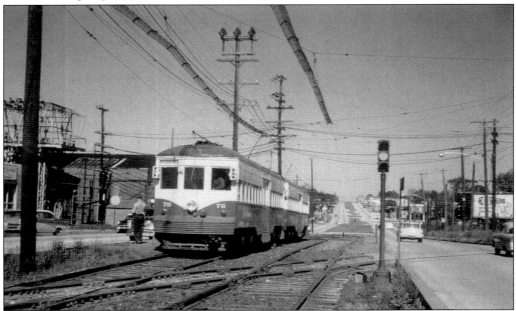

On June 4, 1961, Philadelphia Suburban Transportation Company center door car Nos. 76 and 66 are on West Chester Pike at the Pennsylvania Railroad crossing in Llanerch, which is in the southern part of Haverford Township. The Llanerch carbarn was just behind the trolleys. Looking west the green median strip beyond the tracks was once the West Chester trolley line. (Photograph by Kenneth C. Springirth.)

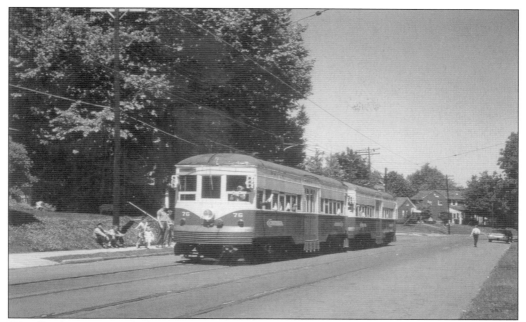

Woodland Avenue at Shisler Avenue in the picturesque borough of Aldan provides a photograph stop for a rail excursion using center door car Nos. 76 and 66 on June 4, 1961, heading southbound on the Sharon Hill line. Students of transportation from all parts of the United States flocked to these trips. (Photograph by Kenneth C. Springirth.)

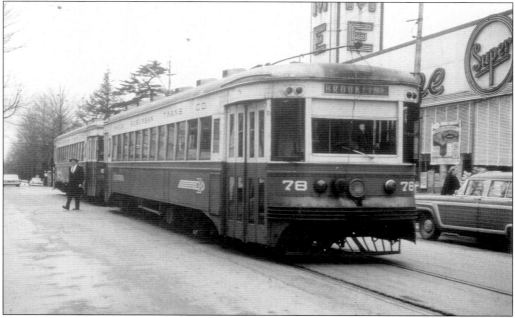

Philadelphia Suburban Transportation Company vintage J. G. Brill Car Company–built car Nos. 78 and 82 are on State Street just west of Orange Street at the end of the line in the borough of Media on April 1, 1962. The 10 cars of this series handled a variety of regular rush-hour and school trips. (Photograph by Kenneth C. Springirth.)

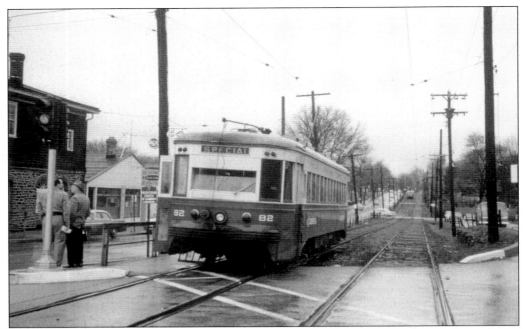

Philadelphia Suburban Transportation Company car No. 82 is at Darby Road on the Ardmore line ready to turn onto West Chester Pike heading for Sixty-ninth Street with car No. 78 in the distance on April 1, 1962. With a wide variety of vintage trolleys available, this system was a favorite for rail excursions. (Photograph by Kenneth C. Springirth.)

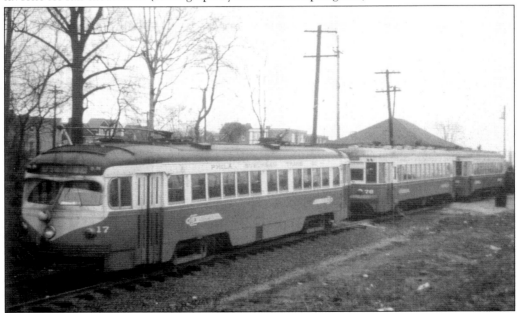

At the terminus of the Sharon Hill line on April 1, 1962, regular service car No. 17 built by St. Louis Car Company in 1949 displays a streamline look compared with car Nos. 78 and 82 built by J. G. Brill Car Company in 1932. The roof of the Sharon Hill trolley station marks the end of the line at Chester Pike. (Photograph by Kenneth C. Springirth.)

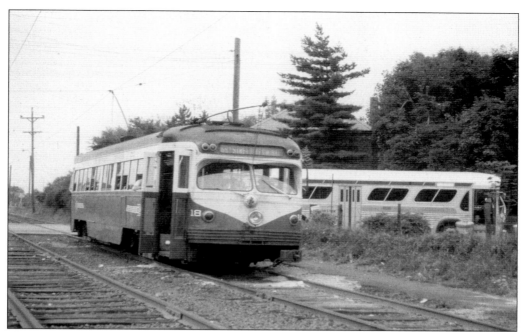

Philadelphia Suburban Transportation Company car No. 18 is at Penn Avenue in the borough of Clifton Heights on July 21, 1962. Track work on Woodland Avenue in the borough of Aldan necessitated a shuttle bus operation from this point south to the terminus in the borough of Sharon Hill. (Photograph by Kenneth C. Springirth.)

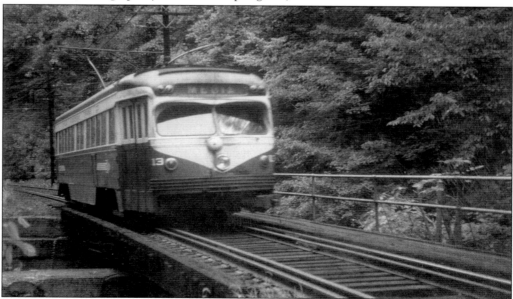

Westbound for the borough of Media, Philadelphia Suburban Transportation Company car No. 13 crosses the Crum Creek Bridge at Smedley Park on September 29, 1962. Although the bridge foundation was built for double track, the one-and-a-half-mile section of the Media line from Woodland Avenue to Interstate 476 is still single track in February 2007. State Street in the borough of Media is also single track. (Photograph by Kenneth C. Springirth.)

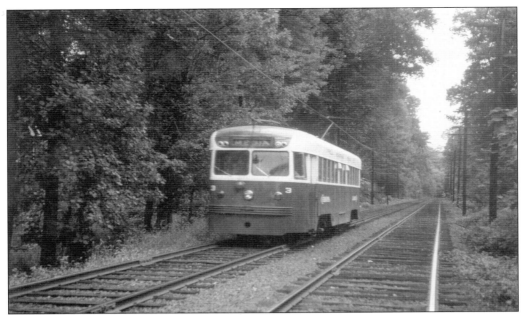

Philadelphia Suburban Transportation Company car No. 3 is westbound to the borough of Media on September 29, 1962. Between Woodland Avenue in Springfield Township and Beatty Road just east of the borough of Media, the trolley line is still in a wooded area in 2007 with a highly populated residential and commercial area in close proximity. (Photograph by Kenneth C. Springirth.)

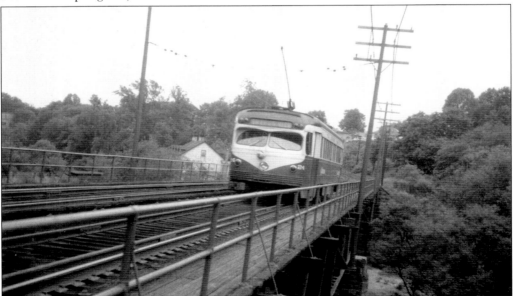

Oakview Trestle over Darby Creek on June 2, 1963, is the setting for car No. 24 on the 5.3-mile Sharon Hill line with Baltimore Pike in the borough of Clifton Heights just around the bend. While infrastructure improvements have been made to the trolley line, the area in 2007 still has abundant woodlands. There is a pleasant street running section through the borough of Aldan. (Photograph by Kenneth C. Springirth.)

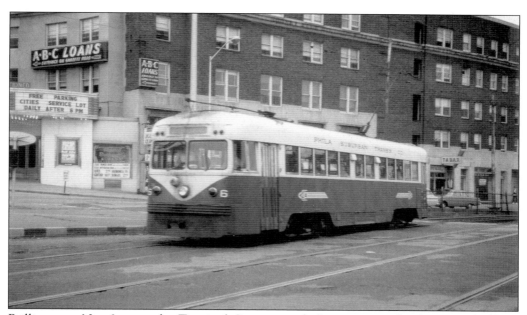

Brilliner car No. 6 passes by Terminal Square just before entering the Sixty-ninth Street Terminal on June 2, 1963. This trolley was part of an order of 10 cars numbered 1–10, which were the last trolleys built by J. G. Brill Car Company in 1941. Philadelphia Suburban Transportation Company adopted a paint scheme with the upper half of the car cream and lower half Tuscan red. (Photograph by Kenneth C. Springirth.)

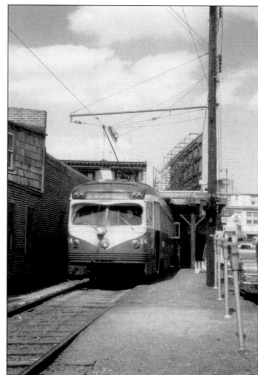

Car No. 14, built by St. Louis Car Company in 1949, has just pulled into the Ardmore terminal on April 16, 1965. This car was one of 14 cars acquired by the Philadelphia Suburban Transportation Company to meet the increased ridership in the growing suburbs. (Photograph by Kenneth C. Springirth.)

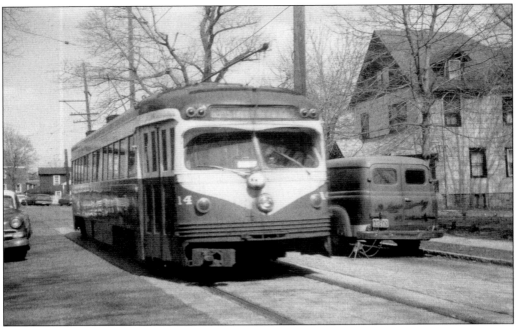

Car No. 14 is heading back to the Sixty-ninth Street Terminal on the Ardmore line on April 16, 1965. With the exception of barn movements from Llanerch carbarn to the Sixty-ninth Street Terminal and back, the Ardmore trolley line was the last line to use West Chester Pike for regular public transit service. (Photograph by Kenneth C. Springirth.)

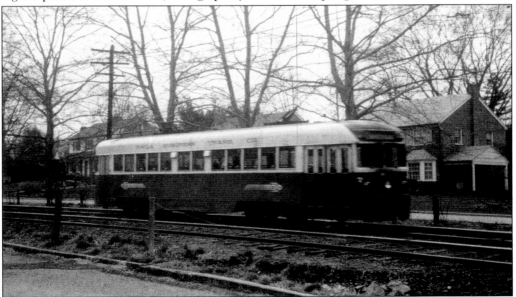

Philadelphia Suburban Transportation Company car No. 7 built by J. G. Brill Car Company in 1941 speeds along the private right-of-way north of the Oakmont section of Haverford Township on the Ardmore line on April 6, 1965. The Ardmore trolley line was largely a private unpaved right-of-way with a paved roadway on each side of the trackage with many paved street crossings. (Photograph by Kenneth C. Springirth.)

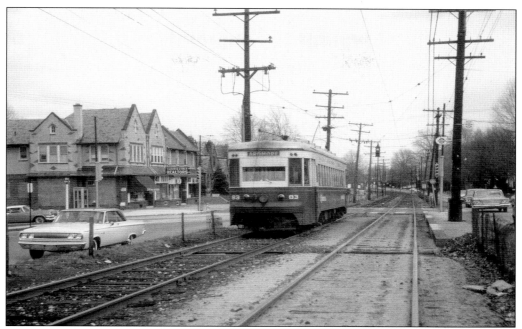

Car No. 83 has just crossed Manoa Road northbound on Darby Road on the Ardmore line on April 16, 1965. The Philadelphia Suburban Transportation Company filed a petition with the Pennsylvania Public Utility Commission to convert the Ardmore trolley line to bus operation and in the March 30, 1965, hearing noted that the Ardmore line lost $40,917 in 1964. (Photograph by Kenneth C. Springirth.)

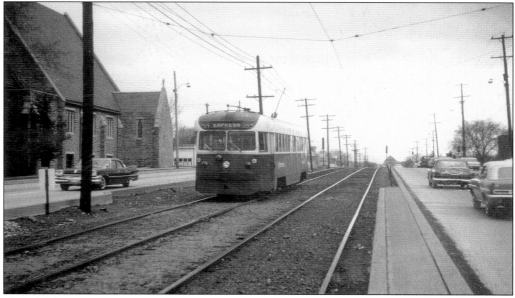

Philadelphia Suburban Transportation Company car No. 9 is on West Chester Pike at Cedar Lane eastbound for the Sixty-ninth Street Terminal on the Ardmore line on April 16, 1965. There was opposition to the company's proposal to convert the line to bus operation with expert testimony noting that the trolley line made $9,000 in 1964. (Photograph by Kenneth C. Springirth.)

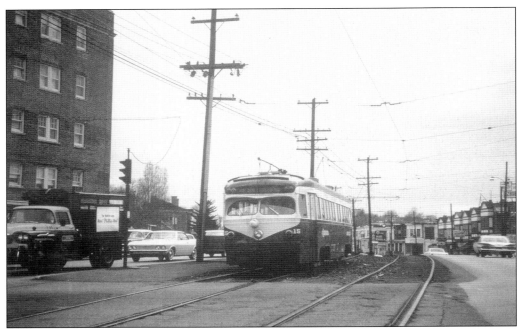

Under cloudy skies, Philadelphia Suburban Transportation Company car No. 15 is on West Chester Pike at Brief Avenue on the Ardmore line just a short distance from the Sixty-ninth Street Terminal on April 16, 1965. Time was running out for the Ardmore line, but serious questions were raised about the proposal to convert the line to bus operation. (Photograph by Kenneth C. Springirth.)

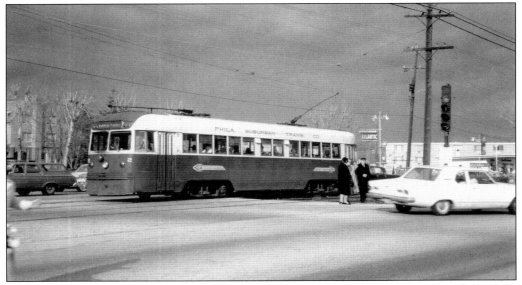

Brilliner car No. 2 is westbound on West Chester Pike on the Ardmore line on April 16, 1965. Built by J. G. Brill Car Company in 1941, this car had riveted construction compared to the welded body construction of Presidents' Conference Committee cars. With a vanishing market the company was dissolved in 1944 and replaced by the ACF Brill Motors Company, which ceased production in 1954. (Photograph by Kenneth C. Springirth.)

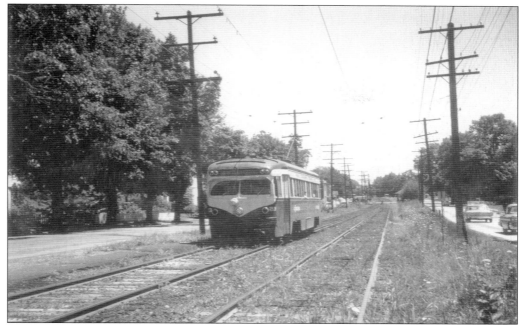

Ardmore car No. 23 is at Darby Road at Mill Road on July 22, 1966. The Pennsylvania Public Utility Commission had announced on June 27, 1966, that permission had been granted to convert the Ardmore trolley line to bus operation, but there was no indication when the actual abandonment would take place because two townships and several people appealed the decision. (Photograph by Kenneth C. Springirth.)

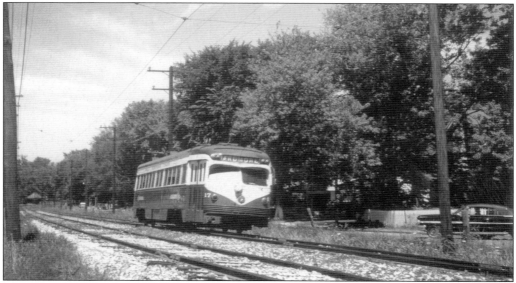

West Hathaway Lane and Huntington Lane on a sunny July 22, 1966, has car No. 17 on the Ardmore line. Approval had been received to convert the line to bus operation. Competent technical witnesses testified that bus substitution would be more costly to operate, add to the heavy traffic on Darby Road, require more travel time, and be unreliable during winter storms. (Photograph by Kenneth C. Springirth.)

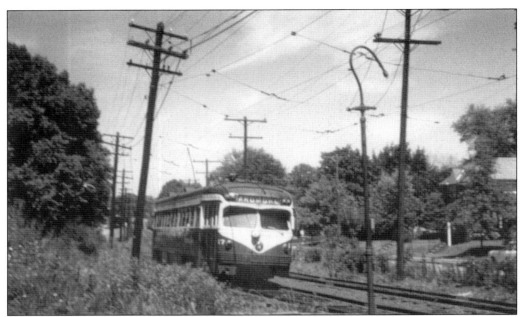

On July 22, 1966, Philadelphia Suburban Transportation Company car No. 17 is at Hathaway Lane and Merwood Lane on the Ardmore line. Following conversion of this line to bus operation on December 30, 1966, a portion of the line was paved over for a private busway for the replacement route R buses. (Photograph by Kenneth C. Springirth.)

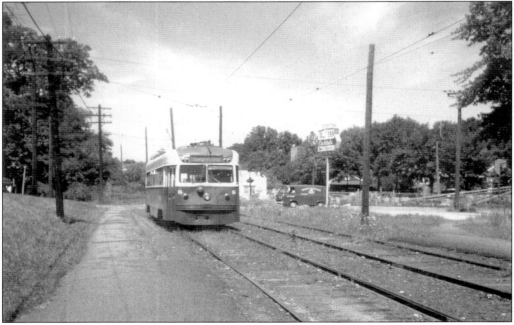

At Ardmore Junction on July 22, 1966, Brilliner car No. 6 is northbound on the Ardmore line. This was a transfer point for the Sixty-ninth Street to Norristown High Speed Line. Effective December 30, 1966, buses replaced the Ardmore trolleys, and this section of the line was paved into a private busway. (Photograph by Kenneth C. Springirth.)

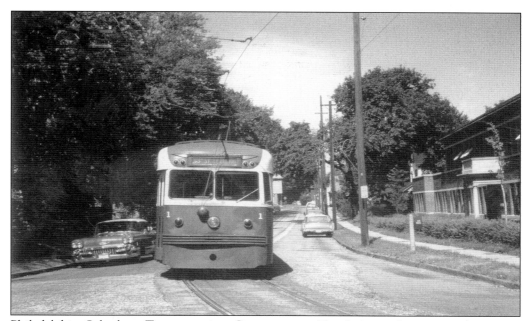

Philadelphia Suburban Transportation Company car No. 1 is on Lippincott Avenue at County Line Road on July 22, 1966, bound for the Sixty-ninth Street Terminal. In 2007, the Southeastern Pennsylvania Transportation Authority bus route 103 uses Ardmore Avenue to reach the Ardmore terminus and Cricket Avenue after leaving the terminal. Lippincott Avenue was considered too narrow for the replacement bus. (Photograph by Kenneth C. Springirth.)

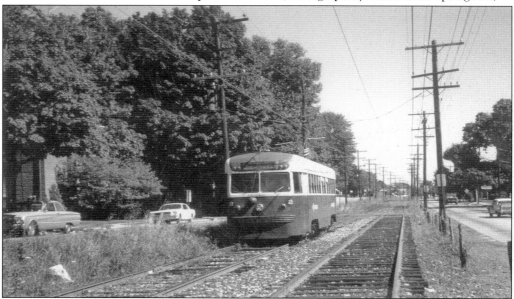

Darby Road south of Eagle Road finds Philadelphia Suburban Transportation Company car No. 2 heading for Ardmore on July 22, 1966. This was the last summer for trolley car service on the Ardmore line. Following replacement with buses on December 30, 1966, these tracks were torn out, but trackage remained on West Chester Pike to reach the Llanerch carbarn. (Photograph by Kenneth C. Springirth.)

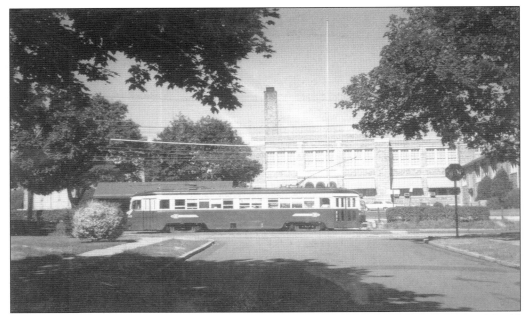

On the afternoon of July 22, 1966, Philadelphia Suburban Transportation Company car No. 17 speeds alongside Darby Road at Yale Road on the Ardmore line. Following World War II, trolley car riding declined, and replacement by buses continued that decline as automobile ownership increased, employment in Center City Philadelphia decreased, and suburban shopping malls diminished the role of the Sixty-ninth Street shopping district. (Photograph by Kenneth C. Springirth.)

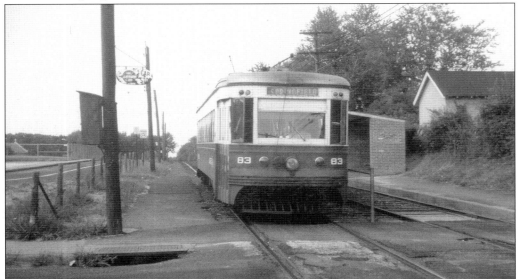

Car No. 83, built by J. G. Brill Car Company, is at Leamy Avenue handling a rush-hour tripper to Woodland Avenue in Springfield Township on the Media line on July 22, 1966. This car made the last trolley trip on the Ardmore line returning to the Sixty-ninth Street Terminal on December 30, 1966, at 2:00 a.m. when Philadelphia Suburban Transportation Company converted the line to bus operation. (Photograph by Kenneth C. Springirth.)

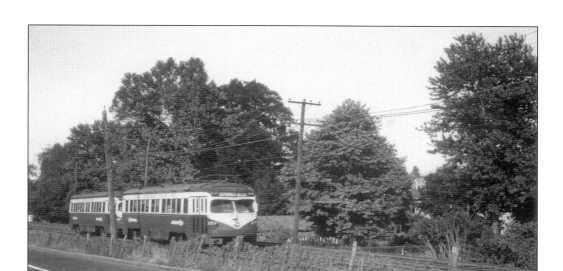

East of Leamy Avenue, St. Louis Car Company–built car Nos. 17 and 13, operating as a two-car train, are handling a rush-hour assignment to Woodland Avenue in Springfield Township on July 22, 1966, on the Media line. Ridership during morning and afternoon peak periods was still heavy. (Photograph by Kenneth C. Springirth.)

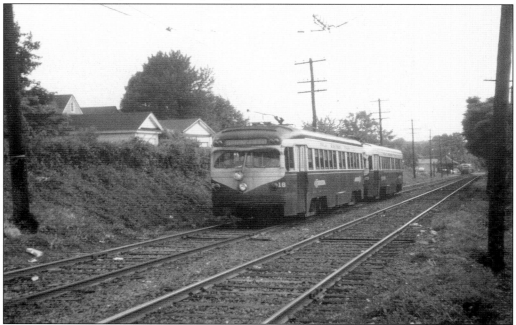

A two-car train consisting of car Nos. 16 and 20 has just left Woodland Avenue in Springfield Township and is approaching Leamy Avenue for the eastbound trip to the Sixty-ninth Street Terminal on the Media line on July 22, 1966. An 80 series J. G. Brill Car Company–built trolley is shown at the distant Woodland Avenue station. (Photograph by Kenneth C. Springirth.)

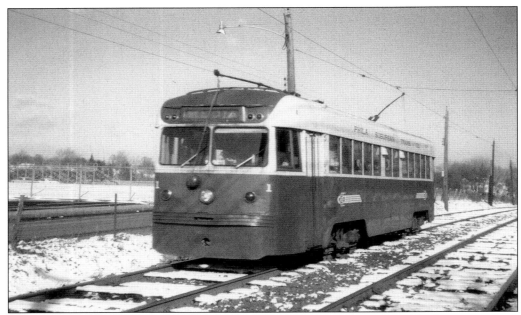

With a dusting of snow, Philadelphia Suburban Transportation Company car No. 1 is approaching Leamy Avenue station westbound to the borough of Media on December 24, 1967, with the athletic field of Springfield High School to the left of the trolley. Both the Media and Sharon Hill trolley lines with their extensive private right-of-way have been dependable transit routes during snowstorms. (Photograph by Kenneth C. Springirth.)

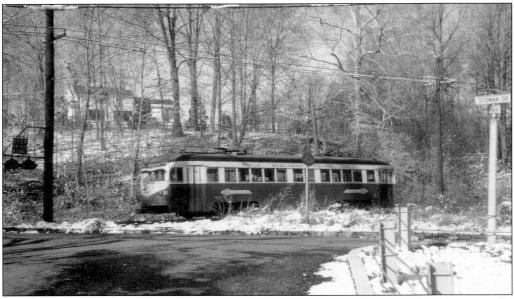

Stidman Drive at Thompson Avenue east of the Sproul Road Bridge provides the setting for Philadelphia Suburban Transportation Company car No. 11 westbound to the borough of Media on December 24, 1967. Although new housing and retail developments have sprouted nearby, the Media trolley continues to be the picturesque line to see and ride. (Photograph by Kenneth C. Springirth.)

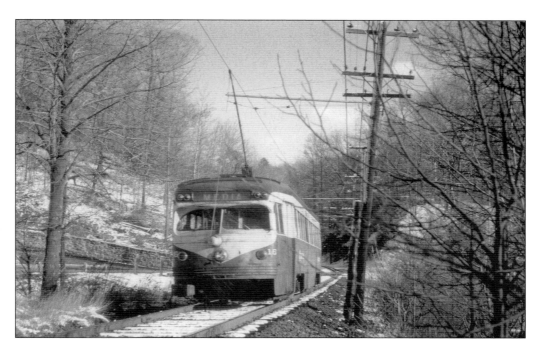

Paper Mill Road at scenic Smedley Park finds car No. 16 gliding by on the Media line eastbound to the Sixty-ninth Street Terminal on December 24, 1967. While this has the look of a rural area, busy Baltimore Pike is a short distance south of the trolley line and Interstate 476 is west of this location. (Photograph by Kenneth C. Springirth.)

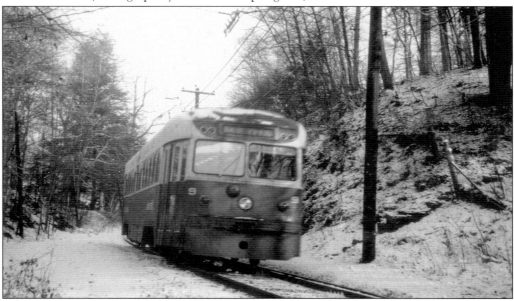

Philadelphia Suburban Transportation Company car No. 9, built by J. G. Brill Car Company, is midway between Smedley Park and Pine Ridge westbound for Media on December 24, 1967. In 2007, with the exception of single track on State Street in Media and a one-and-a-half-mile section of single track between Woodland Avenue and Interstate 476, the remainder of the Media line is double track. (Photograph by Kenneth C. Springirth.)

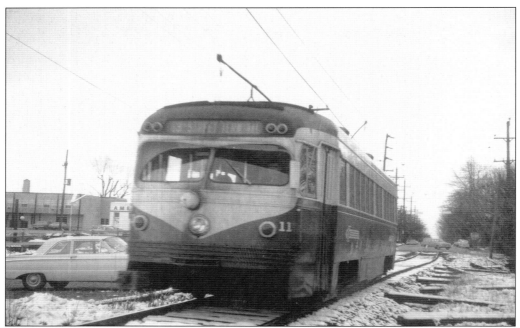

Philadelphia Suburban Transportation Company car No. 11 has just left State Street at Providence Road in the borough of Media heading east for the Sixty-ninth Street Terminal on December 24, 1967. The Media line later had double track from this location east to Interstate 476 where it became single track and double track resumed from Woodland Avenue to the Sixty-ninth Street Terminal. (Photograph by Kenneth C. Springirth.)

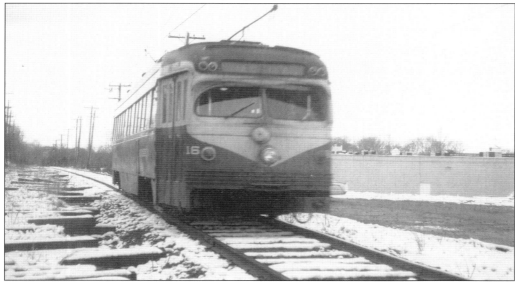

Westbound for the borough of Media on December 24, 1967, car No. 16 is approaching Providence Road where it will enter the street-running trackage on State Street. Retaining the Media trackage has been important because any shuttle bus service from downtown Media to this point would increase travel time to the Sixty-ninth Street Terminal. (Photograph by Kenneth C. Springirth.)

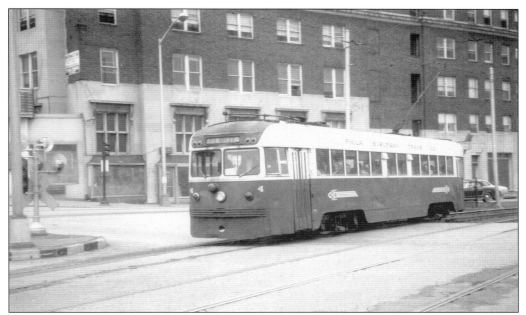

Car No. 4 is at Terminal Square coming into the Sixty-ninth Street Terminal on April 27, 1968. The original terminal was built in 1907 as a joint project of the Philadelphia Rapid Transit Company, the Philadelphia and West Chester Traction Company, and the Philadelphia and Western Railway Company. (Photograph by Kenneth C. Springirth.)

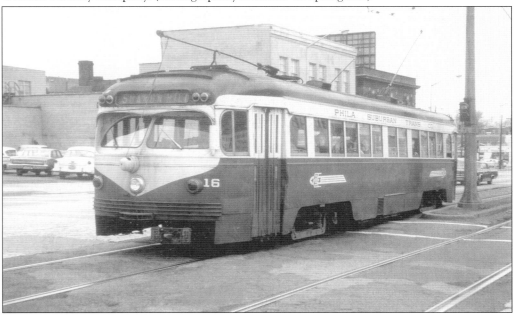

Terminal Square is the location for car No. 16 on its way to the borough of Sharon Hill on April 27, 1968. The Philadelphia Suburban Transportation Company rebuilt its portion of the Sixty-ninth Street Terminal in 1936 to handle many new bus lines and provide a better connection for bus and trolley riders to the Market-Frankford Subway-Elevated Line. (Photograph by Kenneth C. Springirth.)

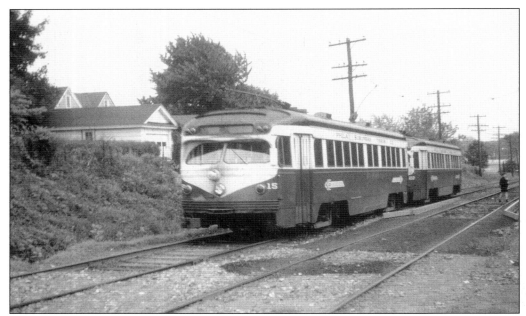

On May 31, 1968, a two-car train (car Nos. 15 and 22) is at Leamy Avenue on the Media line. The special paved area and steel guides were installed for a proposed railbus. In May 1968, the Philadelphia Suburban Transportation Company filed an application with the Pennsylvania Public Utility Commission to operate both railbuses and trolleys on the Media line. (Photograph by Kenneth C. Springirth.)

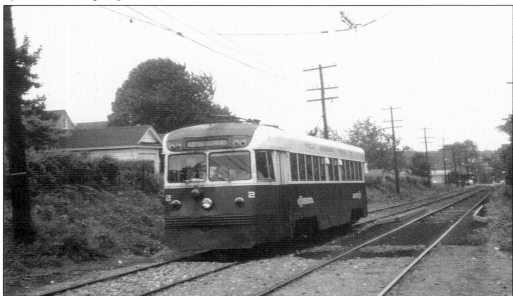

Car No. 2 is at Leamy Avenue on the Media line on May 31, 1968. In addition to the railbus application to the Pennsylvania Public Utility Commission, the Philadelphia Suburban Transportation Company also filed an application to pave between the rails so that both buses and trolleys could be run on both the Media and Sharon Hill trolley lines. The company later withdrew both applications. (Photograph by Kenneth C. Springirth.)

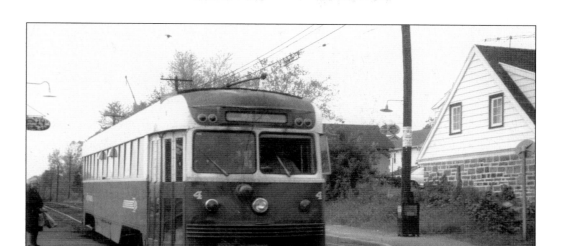

After pausing for a quick passenger stop at Leamy Avenue, Philadelphia Suburban Transportation Company car No. 4 continues westbound for the borough of Media on May 31, 1968. During the afternoon rush hour, Media trolleys would operate express for a portion of the line from the Sixty-ninth Street Terminal to speed up service. Cars to Woodland Avenue in Springfield Township would make all the stops. (Photograph by Kenneth C. Springirth.)

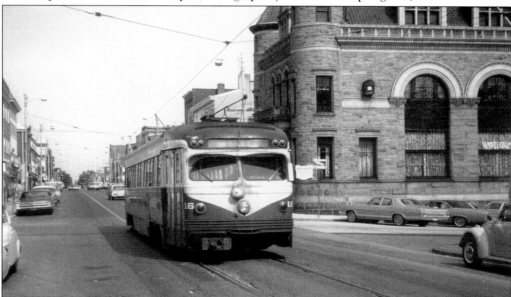

State Street at Veterans Square in the borough of Media finds Philadelphia Suburban Transportation Company car No. 16 westbound for the terminus just west of Orange Street on June 1, 1968. The trolley line has played a positive role in helping to enhance the retail area in Media, which has faced extensive competition from nearby suburban shopping malls. (Photograph by Kenneth C. Springirth.)

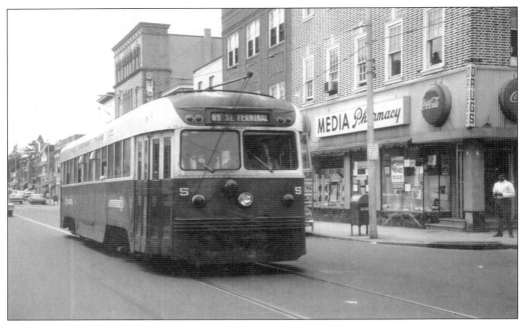

State Street at South Olive Street in the borough of Media finds J. G. Brill Car Company–built car No. 5 eastbound for the Sixty-ninth Street Terminal on June 1, 1968. Looking at the buildings on February 2, 2007, the Media Pharmacy has been replaced by Ten Thousand Villages, a retail handicraft store. (Photograph by Kenneth C. Springirth.)

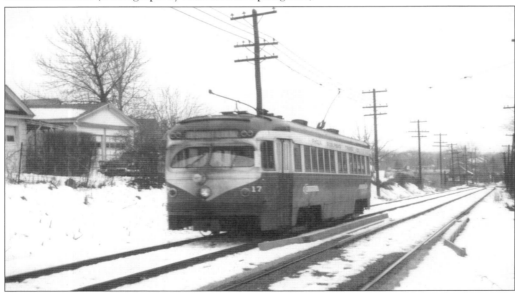

Car no. 17 built by St. Louis Car Company is ready to cross Leamy Avenue eastbound to the Sixty-ninth Street Terminal on February 23, 1969. As negotiations with the Southeastern Pennsylvania Transportation Authority proceeded on a subsidy contract, by February 1969 the Philadelphia Suburban Transportation Company dropped its plans to operate railbuses, and the special railbus guides shown in the picture were later removed. (Photograph by Kenneth C. Springirth.)

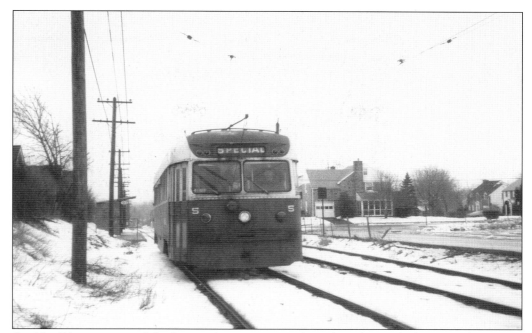

Car No. 5 has just passed the Leamy Avenue stop eastbound on the Media line on February 23, 1969. As ridership continued to decline, the Philadelphia Suburban Transportation Company requested public subsidies just like commuter railroads in the Philadelphia area received. On July 30, 1969, agreement had been reached under which the Southeastern Pennsylvania Transportation Authority would purchase the system. (Photograph by Kenneth C. Springirth.)

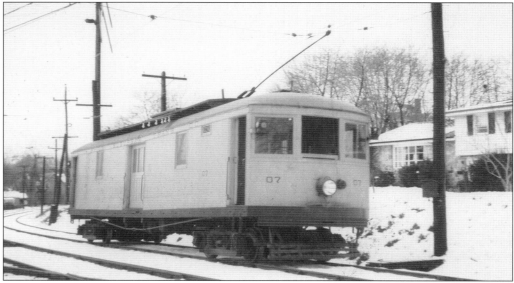

Drexel Hill Junction finds work car No. 07 heading west on the Media line on February 24, 1969. Jewett Car Company built this car for freight service in 1911 for the Philadelphia and West Chester Traction Company. After freight service was discontinued on January 27, 1925, this car was converted into an overhead line car with a roof platform to work on the overhead system. (Photograph by Kenneth C. Springirth.)

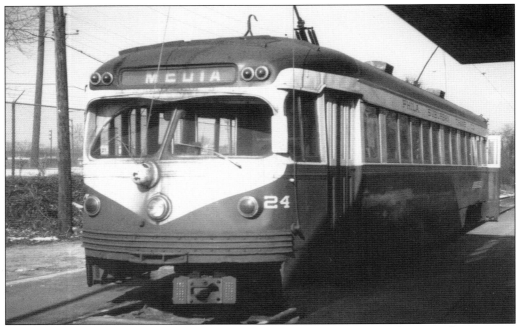

Philadelphia Suburban Transportation Company car No. 24 is at the Sharon Hill station on February 26, 1969. Built by St. Louis Car Company in 1949, this car was equipped for multiple-unit operation. It was used in regular service until 1982 and was acquired by the Pennsylvania Trolley Museum in 1983. (Photograph by Kenneth C. Springirth.)

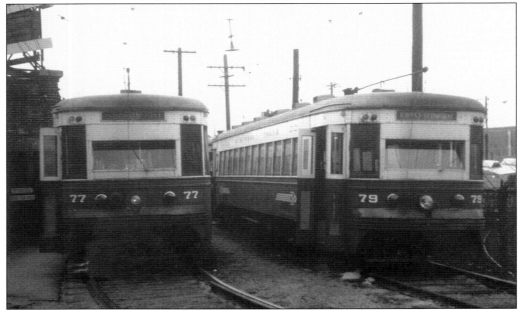

Car Nos. 77 and 79 are at the Sixty-ninth Street Terminal on February 27, 1969, waiting for the next assignment. These trolleys known as Brill master unit–style cars had been delivered by J. G. Brill Car Company in 1932 and featured cushioned leather seats and a faster operating speed to attract riders. (Photograph by Kenneth C. Springirth.)

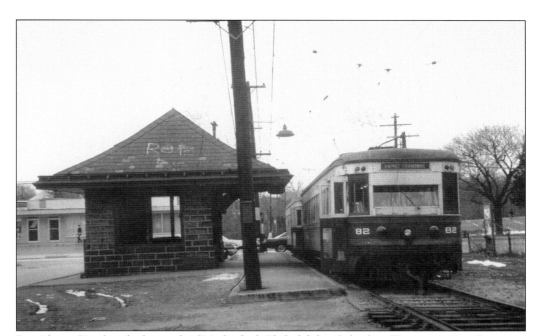

Providence Road in the borough of Media finds Philadelphia Suburban Transportation Company car No. 82 preparing to resume its eastbound trip to the Sixty-ninth Street Terminal on February 28, 1969. As noted in the picture, the sturdy stone station had witnessed senseless vandalism with missing windows and graffiti on the roof. (Photograph by Kenneth C. Springirth.)

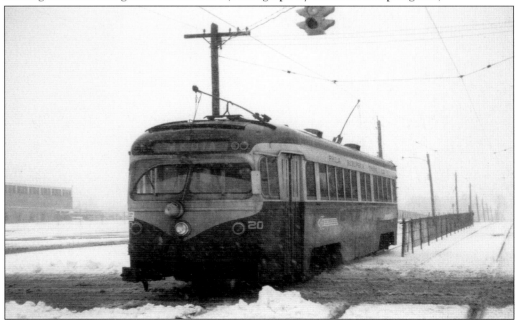

Snow is falling on March 2, 1969, as Philadelphia Suburban Transportation Company car No. 20 crosses Leamy Avenue on its westbound trip on the Media line. This was one of 14 cars numbered 11–24 in 1949 built by St. Louis Car Company and featured two-way radio communications with the dispatcher. (Photograph by Kenneth C. Springirth.)

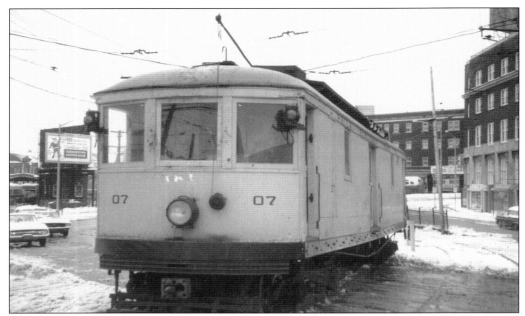

The winter snow finds Philadelphia Suburban Transportation Company line car No. 07 leaving the Sixth-ninth Street Terminal for the next maintenance assignment on December 26, 1969. During snowy weather the company made every effort to keep its rail lines open. On January 29, 1970, the Southeastern Pennsylvania Transportation Authority acquired this company. (Photograph by Kenneth C. Springirth.)

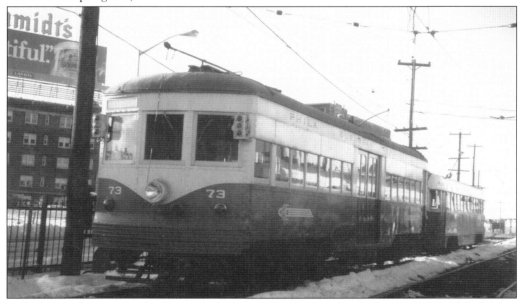

Parked on a siding near the Sixty-ninth Street Terminal on December 26, 1969, Philadelphia Suburban Transportation Company center door car No. 73, built by J. G. Brill Car Company in 1926, was 12 feet 5 inches high and weighed 59,280 pounds, compared with the newer 1941 J. G. Brill Car Company trolley, which was 10 feet high and weighed 42,350 pounds. (Photograph by Kenneth C. Springirth.)

Two

PHILADELPHIA AND WESTERN RAILWAY COMPANY

The Philadelphia and Western Railway Company opened a four-foot, eight-and-a-half-inch railroad gauge line from the Sixty-ninth Street Terminal to Strafford, which is a section of Tredyffrin Township on May 22, 1907. The Lehigh Valley Transit Company had a lengthy trolley route from Allentown to Chestnut Hill that required a transfer to either a commuter train or Philadelphia Rapid Transit Company trolley route 23 to reach Center City Philadelphia. Lehigh Valley Transit Company rebuilt the Montgomery Traction Company line from Lansdale to Norristown. On August 26, 1912, the Philadelphia and Western Railway Company opened a line from Villanova Junction to Norristown. Regular service from Allentown to the Sixty-ninth Street Terminal began on December 12, 1912. During 1931, 10 aerodynamically designed "Bullet cars" built by J. G. Brill Car Company numbered 200 to 209 went into service, which reduced travel time on the Sixty-ninth Street to Norristown line. Passenger riding declined, the company filed for bankruptcy, and a reorganization plan under which the company became a subsidiary of the Philadelphia Suburban Transportation Company was approved by the United States district court on January 16, 1946. Effective September 26, 1949, Lehigh Valley Transit Company through service from Allentown to the Sixty-ninth Street Terminal was cut back to Norristown. On September 6, 1951, the Allentown to Norristown line was converted to bus operation. The Philadelphia and Western Railway became part of the Philadelphia Suburban Transportation Company on December 31, 1953. Declining ridership resulted in the abandonment of the Strafford line from Villanova Junction to Strafford on March 23, 1956, with replacement by route Y buses. On September 26, 1963, two trains known as Electroliners were purchased to operate on the Sixty-ninth Street to Norristown line from the Chicago North Shore and Milwaukee Railroad, which had abandoned service on its Chicago to Milwaukee line on January 21, 1963. Car Nos. 801 and 802 became the Valley Forge and car Nos. 803 and 804 became the Independence Hall. Both trains became known as Liberty Liners and made their inaugural run on the Norristown line on January 26, 1964. On morning trips, coffee and doughnuts were served, and in the afternoon alcoholic beverages were available.

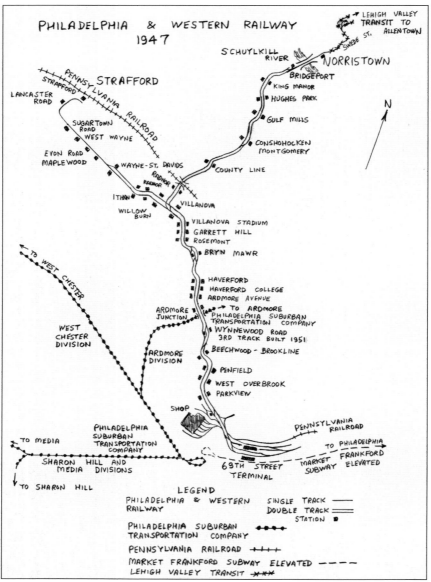

PHILADELPHIA & WESTERN RAILWAY 1947

LEHIGH VALLEY TRANSIT TO ALLENTOWN

SCHUYLKILL RIVER
SWEDE ST.
NORRISTOWN
BRIDGEPORT
KING MANOR
HUGHES PARK
GULF MILLS
CONSHOHOCKEN MONTGOMERY
COUNTY LINE

PENNSYLVANIA RAILROAD
STRAFFORD
STRAFFORD
LANCASTER ROAD
SUGARTOWN ROAD
WEST WAYNE
EVON ROAD MAPLEWOOD
WAYNE-ST. DAVIDS
RADNOR
RADNOR
ITHAN
WILLOW BURN
VILLANOVA
VILLANOVA STADIUM
GARRETT HILL
ROSEMONT
BRYN MAWR
HAVERFORD
HAVERFORD COLLEGE
ARDMORE AVENUE
ARDMORE JUNCTION
TO ARDMORE
PHILADELPHIA SUBURBAN TRANSPORTATION COMPANY
WYNNEWOOD ROAD
3RD TRACK BUILT 1951
BEECHWOOD - BROOKLINE
PENFIELD
WEST OVERBROOK
PARKVIEW

N

TO WEST CHESTER
WEST CHESTER DIVISION
ARDMORE DIVISION

SHOP
PENNSYLVANIA RAILROAD

PHILADELPHIA SUBURBAN TRANSPORTATION COMPANY
TO MEDIA
SHARON HILL AND MEDIA DIVISIONS
TO SHARON HILL
69TH STREET TERMINAL
TO PHILADELPHIA
MARKET FRANKFORD SUBWAY ELEVATED

LEGEND
PHILADELPHIA & WESTERN RAILWAY
PHILADELPHIA SUBURBAN TRANSPORTATION COMPANY
PENNSYLVANIA RAILROAD ++++
MARKET FRANKFORD SUBWAY ELEVATED ----
LEHIGH VALLEY TRANSIT *-**
SINGLE TRACK ——
DOUBLE TRACK ══
STATION ▪

The Philadelphia and Western Railway from the Sixty-ninth Street Terminal to the community of Strafford was constructed as a grade-separated four-foot, eight-and-a-half-inch railroad gauge line with a third rail for power supply. Lehigh Valley Transit operated a trolley line from Allentown to Chestnut Hill. The Philadelphia and Western Railway built an extension from Villanova Junction to Norristown. A new routing was completed by Lehigh Valley Transit into Norristown and used Philadelphia and Western Railway trackage to reach the Sixty-ninth Street Terminal. Through service was discontinued to the Sixty-ninth Street Terminal by Lehigh Valley Transit Company on September 26, 1949, and the Allentown to Norristown line became a bus line on September 6, 1951. Philadelphia and Western Railway was merged into the Philadelphia Suburban Transportation Company on December 31, 1953. The line from Villanova Junction to Strafford was abandoned on March 23, 1956. Under the Southeastern Pennsylvania Transportation Authority, the Norristown line has been refurbished.

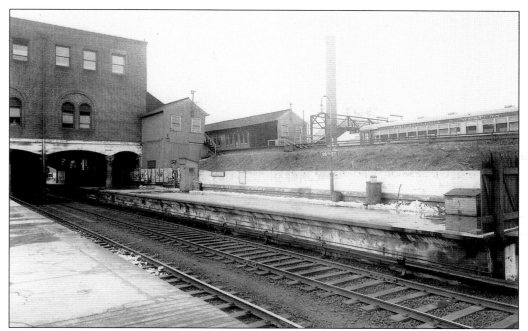

The Market-Frankford Subway-Elevated Line unloading platform at the Sixty-ninth Street Terminal in Upper Darby Township in this view taken by the Philadelphia Rapid Transit Company on January 7, 1936, provides a clear view of the Philadelphia and Western Railway terminal and cars shortly before the terminal was reconstructed. (Matthew W. Nawn collection.)

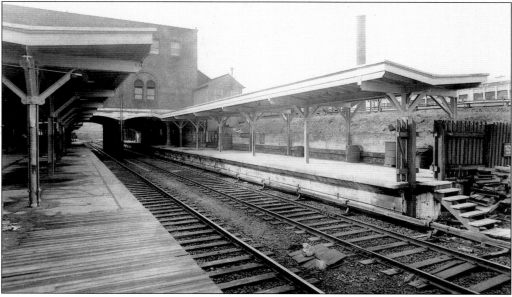

The rebuilt Sixty-ninth Street Market-Frankford Subway-Elevated Line platform complete with the new roofs is shown in this March 3, 1936, photograph taken by the Philadelphia Rapid Transit Company. This terminal was a key component in the development of the Sixty-ninth Street shopping district. Philadelphia and Western Railway cars can still be seen in this view. (Matthew W. Nawn collection.)

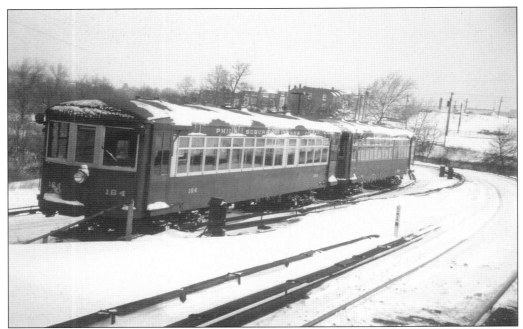

On December 12, 1960, former Philadelphia and Western Railway, now Philadelphia Suburban Transportation Company, car No. 164 is at the Sixty-ninth Street Terminal. This was originally car No. 64 built by J. G. Brill Car Company in 1927 for two-man operation and was later refurbished for one-man operation. (Photograph by Kenneth C. Springirth.)

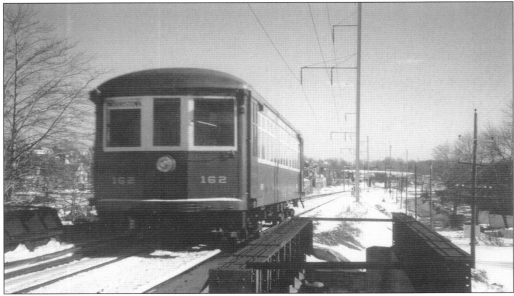

Ardmore Junction, where the Norristown High Speed Line crosses over the Ardmore trolley line, is the scene for former Philadelphia and Western Railway, now Philadelphia Suburban Transportation Company, car No. 162 (original car No. 62) on January 29, 1961. This was the last car of the 160 series in service and was retired on March 30, 1990. (Photograph by Kenneth C. Springirth.)

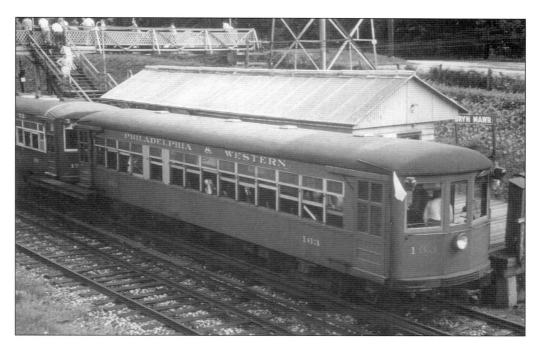

Car No. 163 (original car No. 63) and car No. 170 (original car No. 70), still lettered Philadelphia and Western Railway, are at the Bryn Mawr station on June 4, 1961, on a rail enthusiast excursion. This line, built without any grade crossings with roads or other railroads, became part of the Philadelphia Suburban Transportation Company on December 31, 1953. (Photograph by Kenneth C. Springirth.)

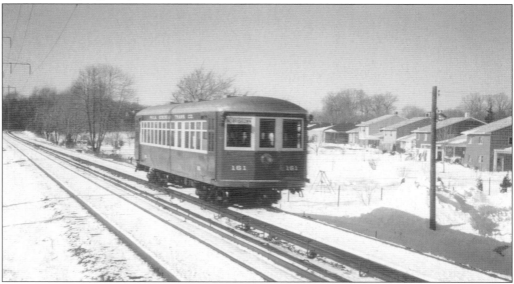

Northbound for Norristown, Philadelphia Suburban Transportation Company car No. 161 (original car No. 61) has just left Ardmore Junction on January 29, 1961. After the Strafford line was abandoned on March 23, 1956, this type of car handled rush-hour runs on the Sixty-ninth Street to Norristown line. This car is now at the New York Museum of Transportation at West Henrietta, New York. (Photograph by Kenneth C. Springirth.)

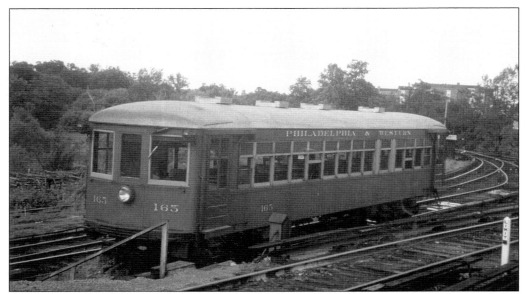

Philadelphia and Western Railway (later Philadelphia Suburban Transportation Company) car No. 165 (original car No. 60) is at the Sixth-ninth Street Terminal on June 4, 1961. This car, built by J. G. Brill Car Company in 1924, was retired on August 23, 1986. It was sold to the Keokuk Junction Railway and was later rebuilt as a gas car for El Reno, Oklahoma. (Photograph by Kenneth C. Springirth.)

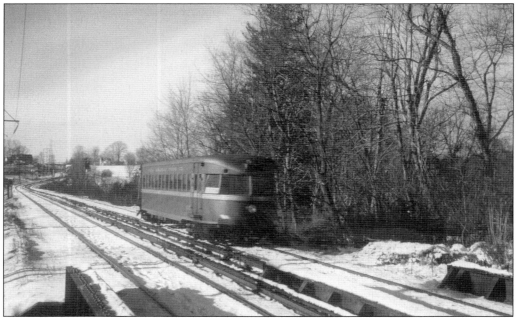

A 200 series Bullet car has left Rosemont station for Norristown on February 25, 1962. Dr. Thomas Conway was hired by the Philadelphia and Western Railway to manage the company, and he became company president on April 29, 1931. He championed the design of 10 new high-speed Bullet-type cars numbered 200–209 built by J. G. Brill Car Company in 1931. (Photograph by Kenneth C. Springirth.)

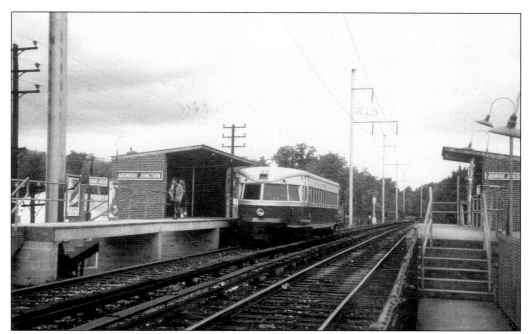

Bullet car No. 204 is at Ardmore Junction on September 29, 1962. University of Michigan professor of aeronautics Felix Pawlowski was hired by the Philadelphia and Western Railway to design a car body using wind tunnel testing and practical experience that ultimately led to the Bullet cars built by J. G. Brill Car Company. (Photograph by Kenneth C. Springirth.)

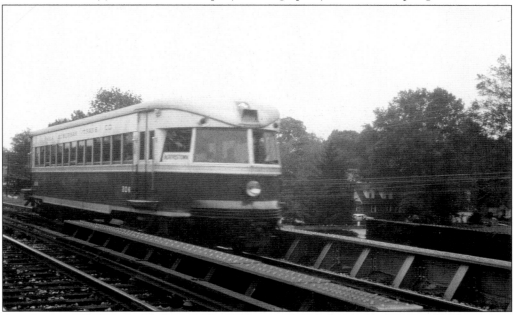

Aerodynamically designed Bullet car No. 204 has just left Ardmore Junction on the Norristown line on September 29, 1962. The 55.16-foot-long car weighed 52,290 pounds. Powered by four 100-horsepower General Electric model 706B motors, the car had a smooth roof design to reduce power consumption. (Photograph by Kenneth C. Springirth.)

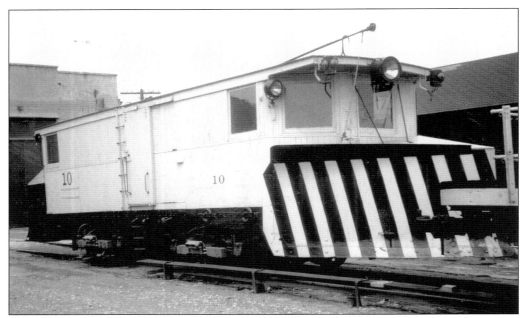

Philadelphia and Western Railway (later Philadelphia Suburban Transportation Company) snowplow No. 10 is at the Sixty-ninth Street Terminal shops on April 27, 1968. This car was built by Wason Car Company in 1915 and is now preserved at the Rockhill Trolley Museum in Rockhill Furnace in Huntingdon County. (Photograph by Kenneth C. Springirth.)

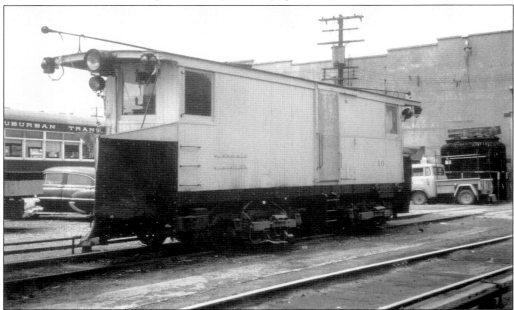

This is another view of Philadelphia and Western Railway snowplow No. 10 at the Sixty-ninth Street Terminal shops on April 27, 1968. While the railroad-gauge Norristown line is third rail operated, the broad-gauge trolley lines have an overhead wire system, which along with the difference in track gauges necessitated separate shop facilities. (Photograph by Kenneth C. Springirth.)

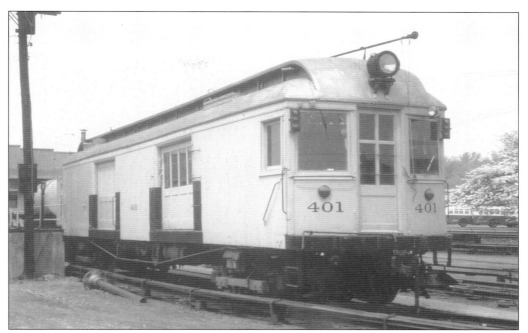

Philadelphia and Western Railway (later Philadelphia Suburban Transportation Company) line car No. 401 is at the shops just west of the Sixty-ninth Street Terminal on April 27, 1968. St. Louis Car Company built this car in 1907. It was retired by the Southeastern Pennsylvania Transportation Authority in 1990 and is at the Electric City Trolley Museum in Scranton. (Photograph by Kenneth C. Springirth.)

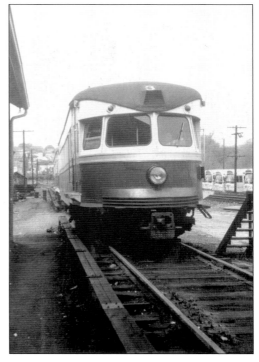

Bullet car No. 203 is at the shops just west of the Sixty-ninth Street Terminal on April 27, 1968. Because of the powered third rail, the Philadelphia and Western Railway had high-level platforms. About 30 different car body designs were tested before production, and the final design represented a compromise between the ideal design and the practical requirements needed, such as adequate passenger headroom. (Photograph by Kenneth C. Springirth.)

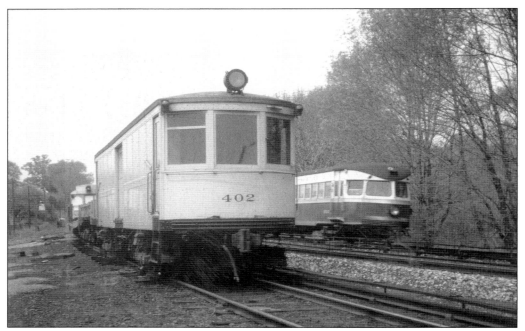

With a northbound Bullet car No. 200 passing by, Philadelphia and Western Railway car No. 402 is at the car shop just west of the Sixty-ninth Street Terminal on April 27, 1968. This car built in 1920 was acquired from the Eastern Michigan Railway in 1943 and has been preserved by the Rockhill Trolley Museum in Rockhill Furnace in Huntingdon County. (Photograph by Kenneth C. Springirth.)

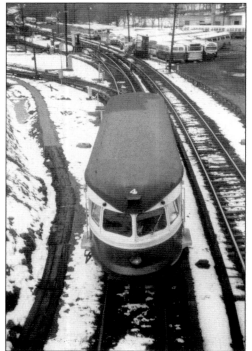

Bullet car No. 204 is quietly approaching the Sixty-ninth Street Terminal with the shops on the left and the bus garage area on the right on February 24, 1969. This car was retired in 1986 and was sold for scrap to the Delaware Car Company of Wilmington, Delaware. The body shell was sold to the Museum of Transportation at St. Louis. (Photograph by Kenneth C. Springirth.)

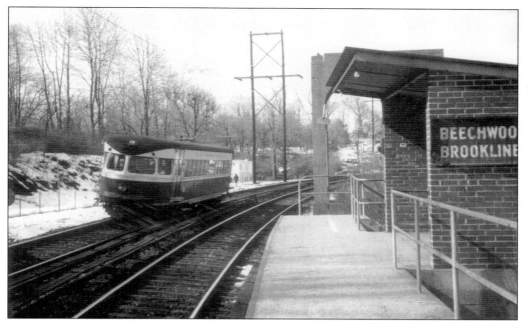

Beechwood-Brookline is the station stop for Bullet car No. 206 on February 27, 1969. This car, built by J. G. Brill Car Company in 1931, was retired on October 29, 1990. It was converted to a "pickle" car used to spray calcium chloride on the third rail to prevent icing and is now on display at the Electric City Trolley Museum at Scranton. (Photograph by Kenneth C. Springirth.)

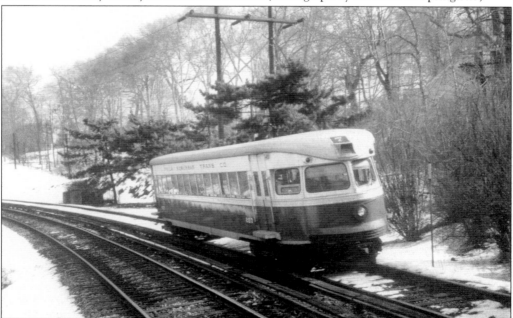

Philadelphia Suburban Transportation Company (former Philadelphia and Western Railway) car No. 207 has just left the Beechwood-Brookline station on February 27, 1969. Based on the extensive wind tunnel research, the smooth-designed car roof dipped down at each end so that the car had the shape of a bullet to conserve energy. (Photograph by Kenneth C. Springirth.)

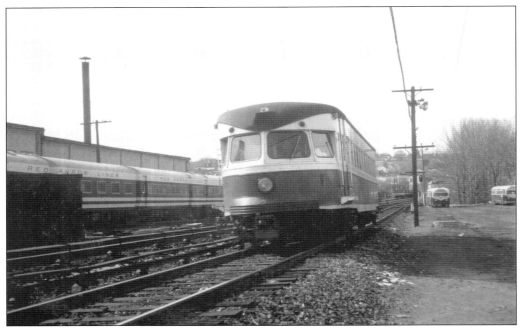

On February 27, 1969, car No. 203 has just left the Sixty-ninth Street Terminal passing by the shops with a Liberty Liner shown on the left. This car was retired during December 1989 after being trucked to Woodland Depot for evaluation and was later sold to the Seashore Trolley Museum at Kennebunkport, Maine. (Photograph by Kenneth C. Springirth.).

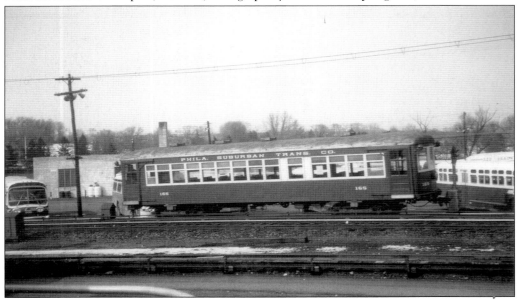

Philadelphia Suburban Transportation Company (original Philadelphia and Western Railway) car No. 165 (original car No. 60) is at the shop near the Sixty-ninth Street Terminal on February 27, 1969. This car was retired on August 23, 1986, and was acquired by the Canadian County Historical Society at El Reno, Oklahoma. Renumbered car No. 145 was modified with a Chevrolet model 454 V-8 engine fueled by propane. (Photograph by Kenneth C. Springirth.)

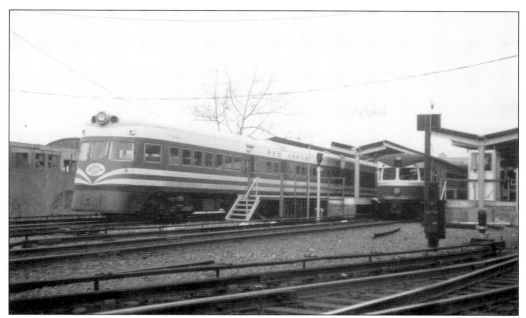

On the left a Liberty Liner is at the Sixty-ninth Street Terminal on February 27, 1969. Purchased from the Chicago North Shore and Milwaukee Railroad, the trolley poles were removed, new doors were added to the center section, third rail contact shoes were installed, and the interiors were completely refurbished. The Liberty Liner required a motorman, two conductors, and a waiter. (Photograph by Kenneth C. Springirth.)

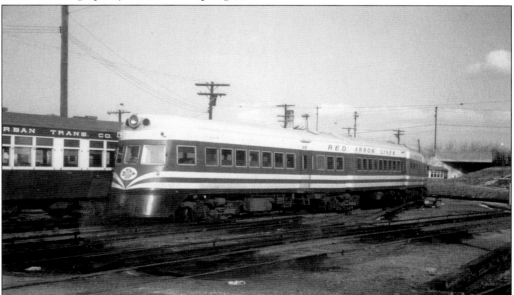

The Sixty-ninth Street shops are the scene for this Liberty Liner on February 27, 1969. The June 24, 1977, *Evening Bulletin* noted Liberty Liners were discontinued for economic reasons on March 24, 1977, commenting, "The interior walls of the bar cars look like they belong in a nursery school. Painted on them are pink and polka-dotted elephants having endless tugs of war with giraffes." (Photograph by Kenneth C. Springirth.)

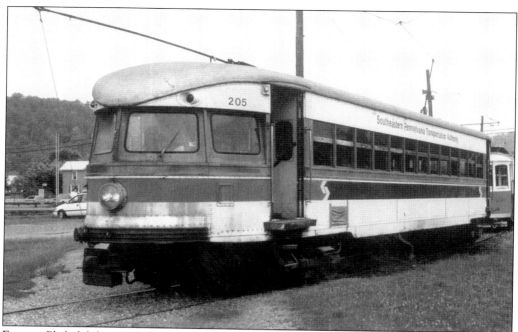

Former Philadelphia and Western Railway car No. 205, built in 1931 by the J. G. Brill Car Company, is at Rockhill Trolley Museum in the borough of Rockhill Furnace in Huntingdon County on June 22, 1996. The Southeastern Pennsylvania Transportation Authority retired this Bullet car on April 5, 1990. (Photograph by Kenneth C. Springirth.)

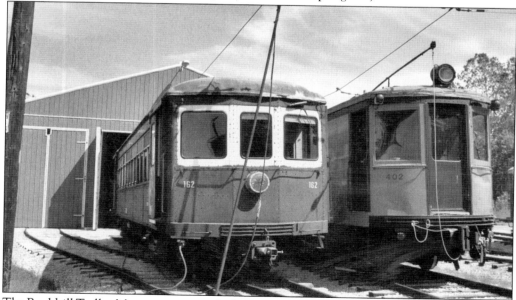

The Rockhill Trolley Museum contains the largest collection of former Philadelphia and Western Railway cars at any museum. Shown at the museum in June 2003 are operational car No. 162, built by J. G. Brill Car Company in 1927 and extensively rebuilt in 1931, and car No. 402 (builder unknown). The 600-volt extension cord used to move car No. 162 is shown in the photograph. (Photograph by Matthew W. Nawn.)

Three

PHILADELPHIA TRANSPORTATION COMPANY DELAWARE COUNTY LINES

On December 24, 1858, the Philadelphia and Darby Railroad Company began operating from downtown Philadelphia to Ninth and Main Streets in the borough of Darby. On March 6, 1893, the Chester and Media Electric Railway began trolley service from Chester to Media. In 1894, the Delaware County and Philadelphia Electric Railway began trolley service along Baltimore Pike from the Angora section of Philadelphia to Media. The Chester to Media and Angora to Media lines became part of the Southern Pennsylvania Traction Company, which operated trolley service in Delaware County until conversion to bus operation was completed on December 15, 1934. Electrification of the Philadelphia to Darby line was completed on May 29, 1894, by the Philadelphia Traction Company. The Philadelphia, Morton, and Swarthmore Street Railway connected Darby with Swarthmore on June 29, 1900, and reached Media on July 4, 1904. A short trolley line from the borough of Darby to the borough of Lansdowne opened on July 4, 1902. Delaware County trolley lines later operated by the Philadelphia Rapid Transit Company included route 71 Darby–Media until August 14, 1938; route 76 Darby–Chester until May 26, 1935; route 77 Chester–Media until April 5, 1936; and route 78 Darby–Lansdowne until June 22, 1947. In 1934, the Philadelphia Rapid Transit Company went into receivership and was reorganized as the Philadelphia Transportation Company on January 1, 1940. National City Lines acquired the Philadelphia Transportation Company during 1955. Many trolley lines were converted to bus operation. In 1955, the extension of the subway was completed. Trolley routes 36 and 37 were combined into route 36 on November 6, 1955, operating from Westinghouse Loop in the community of Lester to Philadelphia. On September 9, 1956, route 36 was cut back to Ninety-fourth Street just inside the Philadelphia city limits. Trolley route 62 connected the end of route 11 in Darby with the end of route 13 in Yeadon. On Sunday June 8, 1958, route 6 Glenside–Willow Grove was converted to bus operation north of the Philadelphia city limits, which left route 11 Darby and route 13 Yeadon as the only trolley lines from Center City operating beyond the city limits.

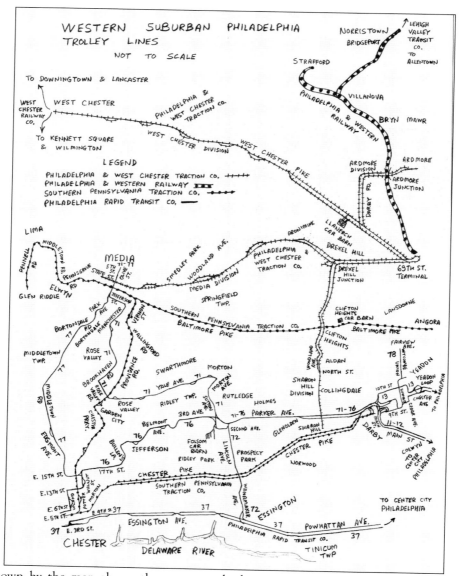

As shown by the map above, the western suburban area of Philadelphia had a number of trolley lines. The Philadelphia Rapid Transit Company had an extensive system in the city of Philadelphia that extended northward to Willow Grove, Hatboro, and Doylestown and westward to Yeadon, Darby, Lansdowne, Media, and Chester. Philadelphia and West Chester Traction Company linked West Chester, Ardmore, Media, and Sharon Hill with the Sixty-ninth Street Terminal where the Market-Frankford Subway-Elevated Line provided service to Center City Philadelphia. At West Chester, connections could be made to Lancaster and Wilmington. Philadelphia and Western Railway connected the Sixty-ninth Street Terminal with Norristown where Lehigh Valley Transit headed north to Allentown. Southern Pennsylvania Traction Company linked the Angora section of Philadelphia with Media and connected Darby with Chester where connections could be made to Wilmington. Schuylkill Valley Traction Company provided city service in Norristown and provided service to Pottstown, where connections could be made for Reading.

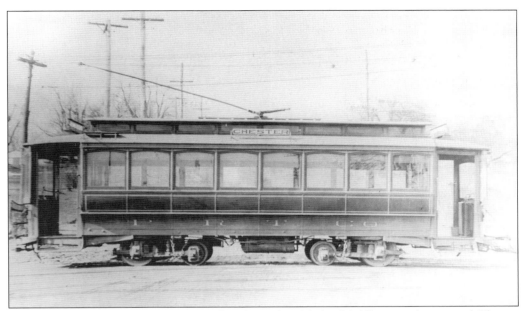

This is a view of a Folsom Division trolley, formerly a Media, Middletown, Aston, and Chester Electric Railway (MMA&C) car from class 21–29. These cars were ordered from J. G. Brill Car Company on June 23, 1899, by the MMA&C predecessor company Philadelphia, Morton, and Swarthmore Street Railway. This class was withdrawn from service in 1919, when replaced by Birney-type cars. (Matthew W. Nawn collection.)

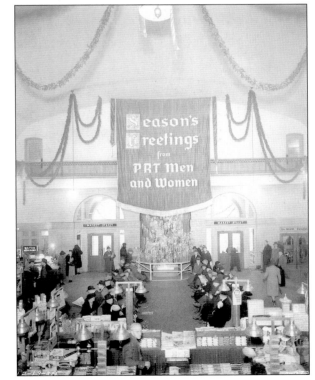

Patrons of the Sixty-ninth Street Terminal were treated to holiday decorations in past years. Philadelphia Rapid Transit Company's 1938 decorations are shown in this view taken on December 19, 1938. People used to dress up to shop in the nearby extensive shopping district. (Matthew W. Nawn collection.)

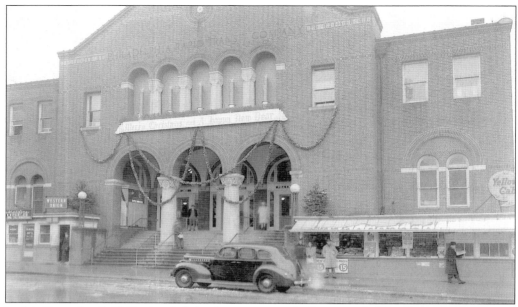

In this December 5, 1940, view, holiday decorations at the Sixty-ninth Street Terminal continued after the formation of the Philadelphia Transportation Company in 1940. As the area continued to grow, along with wartime riding increases, this continued to be an important terminal point. (Matthew W. Nawn collection.)

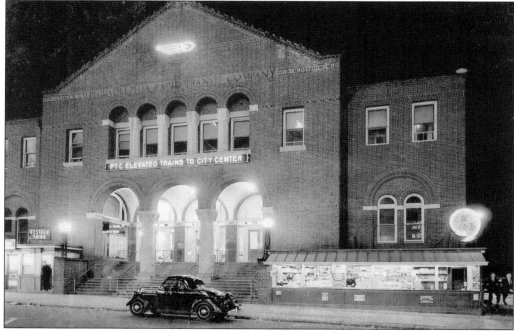

The formation of the Philadelphia Transportation Company in 1940 brought many changes to meet the growing wartime ridership, including a new neon sign at the Sixty-ninth Street Terminal to highlight the Market-Frankford Subway-Elevated Line, which provided fast service to Center City. (Matthew W. Nawn collection.)

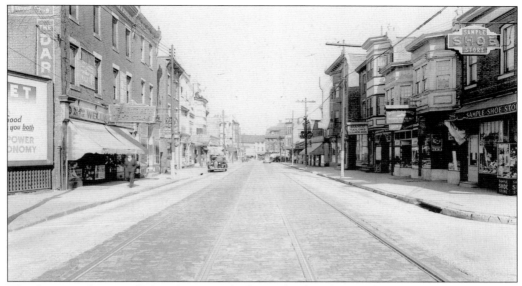

The shopping district of Main Street in the borough of Darby is a thriving business district in this May 16, 1937, photograph taken by the Philadelphia Rapid Transit Company. Photographs like this were often taken as part of an accident investigation involving the company's equipment and personnel. (Matthew W. Nawn collection.)

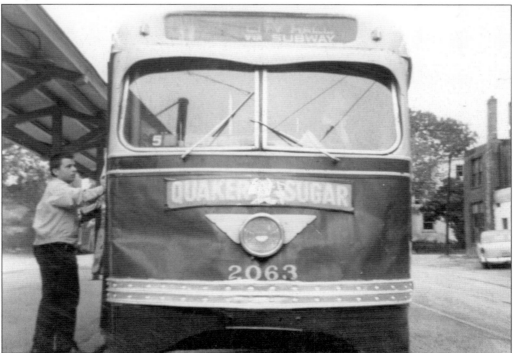

Darby Loop of the Philadelphia Transportation Company is the scene for Presidents' Conference Committee car No. 2063 in 1958. This all-welded steel-body car powered by Westinghouse model 1432D motors was delivered by St. Louis Car Company in February 1941, and it was destroyed in the Woodland Depot fire of October 23, 1975. (Photograph by Kenneth C. Springirth.)

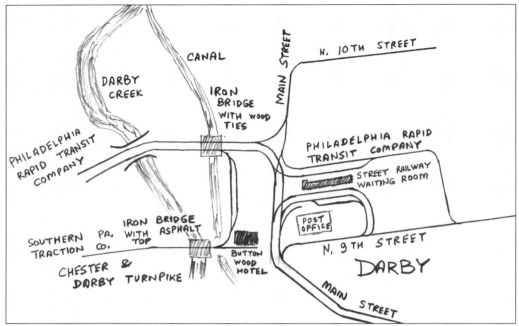

Darby was a transportation center, as evidenced by this sketch of trackage from a reference book maintained at the Darby Free Library by history archives curator Betty Schell. Travelers could reach Center City Philadelphia and make connections for Chester, Media, and a variety of Pennsylvania communities as well as Wilmington, Delaware.

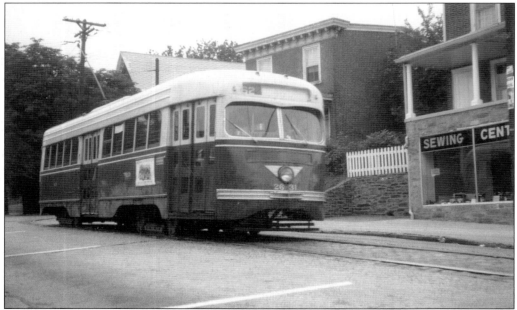

Presidents' Conference Committee car No. 2631 has just turned from Tenth Street to Main Street in the borough of Darby on route 62 on June 2, 1963. St. Louis Car Company delivered this car to the Philadelphia Transportation Company during June 1942. The car, powered by Westinghouse model 1432D motors, was scrapped in 1977. (Photograph by Kenneth C. Springirth.)

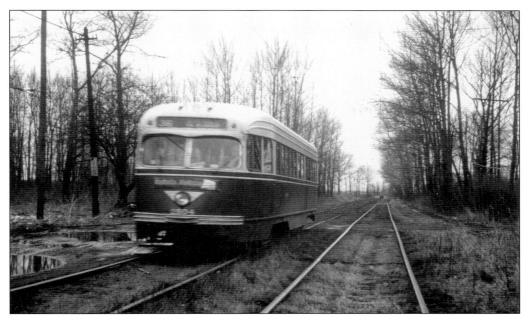

The private right-of-way of route 36 in the Eastwick section of Philadelphia is the setting for Presidents' Conference Committee car No. 2504 on March 18, 1962. St. Louis Car Company delivered this car to the Philadelphia Transportation Company during December 1940 as part of an order for cars numbered 2501–2580. The car, powered by General Electric model 1198F3 motors, was scrapped in 1980. (Photograph by Kenneth C. Springirth.)

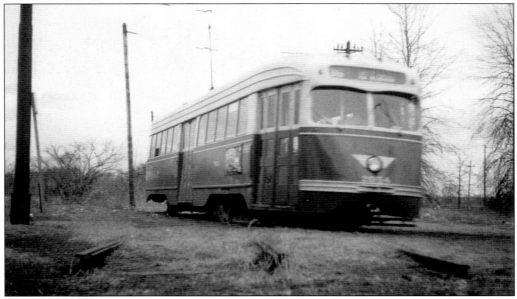

Presidents' Conference Committee car No. 2054 is at the Ninety-fourth Street and Eastwick Avenue Loop of route 36 on March 18, 1962. The Philadelphia Transportation Company received this car during February 1941. To celebrate the 40th anniversary of this car series, during 1980, it was repainted silver with blue trimming. It is now at the Electric City Trolley Museum at Scranton. (Photograph by Kenneth C. Springirth.)

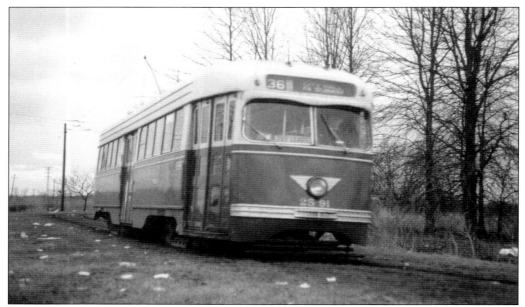

The Ninety-fourth Street and Eastwick Avenue Loop of route 36 provides the setting for Presidents' Conference Committee car No. 2591 on March 18, 1962. The Philadelphia Transportation Company received this car from St. Louis Car Company during May 1942. This car was scrapped in 1981. The trolley line was cut back to Eighty-eighth Street and Eastwick Avenue on August 15, 1962. (Photograph by Kenneth C. Springirth.)

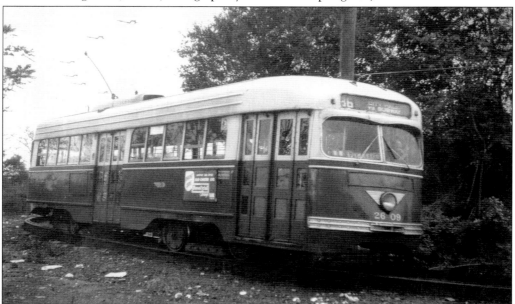

Presidents' Conference Committee car No. 2609 is at the Eighty-eighth Street and Eastwick Avenue Loop of route 36 on September 29, 1962. This car was received by the Philadelphia Transportation Company during June 1942 and was destroyed in the Woodland Depot fire of October 23, 1975. The trolley line was cut back to Eightieth Street and Eastwick Avenue on May 9, 1975. (Photograph by Kenneth C. Springirth.)

Four

SOUTHEASTERN PENNSYLVANIA TRANSPORTATION AUTHORITY TAKES OVER

The Southeastern Pennsylvania Transportation Authority took over the Philadelphia Transportation Company on September 30, 1968, and the Philadelphia Suburban Transportation Company on January 29, 1970. A fire at Woodland Depot on October 23, 1975, destroyed 60 trolley cars and seven work cars. For a time this necessitated buses on route 11. On March 29, 1979, the Southeastern Pennsylvania Transportation Authority awarded a $67.2 million contract to Nissho Iwai American Corporation for 141 new light-rail vehicles to be built by Kawasaki Heavy Industries of Kobe, Japan, the prime contractor for Nissho Iwai. There were 112 single-end units for subway surface routes 10, 11, 13, 34, and 36 and 29 double-ended cars for the Red Arrow Division Media and Sharon Hill lines. During 1979, a new track connection was installed in the borough of Darby on Main Street so that route 13 trolleys could go directly onto route 11 trackage to reach Island Road for access to Elmwood Depot. An early map showed a connection, but in recent years there was no connection even though both routes share the same terminal facilities. On October 10, 1980, Kawasaki Heavy Industries car No. 9000 entered passenger service on route 11 Darby, and car No. 100 entered service on the Media line on November 4, 1980. During the week of June 13, 1982, the last nine Presidents' Conference Committee cars were transferred to the North Philadelphia trolley routes, and all service on the subway surface routes was now provided by the new Kawasaki Heavy Industries cars. On the Red Arrow Division, October 15, 1982, was set as the final day for operation of the older trolleys, but vintage car Nos. 7, 8, 14, 21, and 77 were still serviceable and used until all operators were qualified to operate the Kawasaki Heavy Industries cars. The Southeastern Pennsylvania Transportation Authority discontinued the Liberty Liners on March 24, 1977, the first day of the strike against the authority's city transit division.

The Norristown to the Sixty-ninth Street Terminal line received 26 new stainless steel cars built by Asea Brown Boveri, with the entire service operated by the new cars beginning on April 11, 1994.

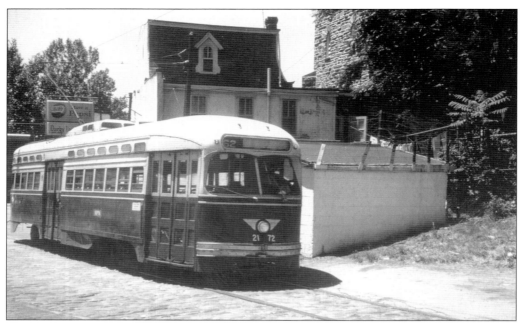

The Darby terminal finds Presidents' Conference Committee car No. 2172 handling the one-car assignment of route 62 (Darby–Yeadon) on May 30, 1970. St. Louis Car Company delivered this car to the Philadelphia Transportation Company during July 1948, and the Southeastern Pennsylvania Transportation Authority scrapped it in 1985. (Photograph by Kenneth C. Springirth.)

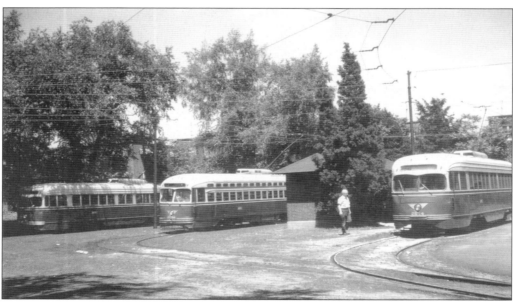

Yeadon Loop is the setting for three Presidents' Conference Committee cars on May 30, 1970. Car No. 2039, delivered in February 1941, was destroyed in the Woodland Depot fire of October 23, 1975. Car No. 2156, delivered in June 1948, was sold in 2004. Car No. 2514, delivered during December 1940, was destroyed in the Woodland carbarn fire of October 23, 1975. (Photograph by Kenneth C. Springirth.)

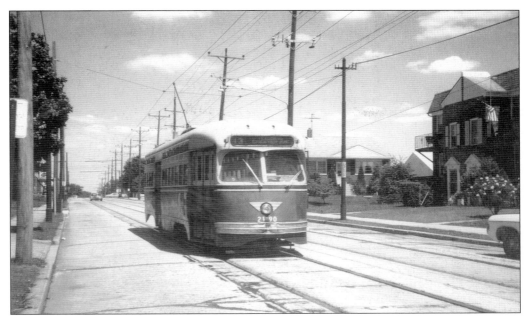

Presidents' Conference Committee car No. 2190 is on Chester Avenue at Stetser Avenue in the borough of Yeadon on the Southeastern Pennsylvania Transportation Authority's route 13 westbound for Yeadon Loop on May 30, 1970. This car was delivered to the Philadelphia Transportation Company during July 1948 by St. Louis Car Company and was sold to a private owner in June 1980 and later resold. (Photograph by Kenneth C. Springirth.)

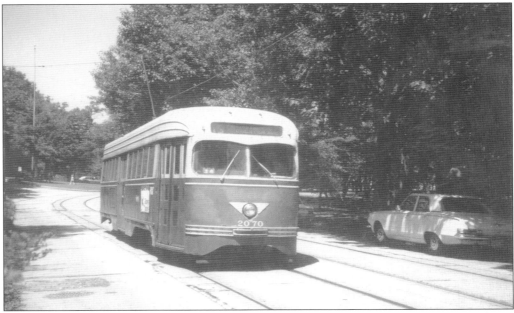

On picturesque Chester Avenue just east of Church Lane in the borough of Yeadon, Presidents' Conference Committee car No. 2070 is westbound on route 13 for Yeadon Loop on May 30, 1970. This car, built by St. Louis Car Company, was delivered in March 1941 and was destroyed in the Woodland Depot fire of October 23, 1975. (Photograph by Kenneth C. Springirth.)

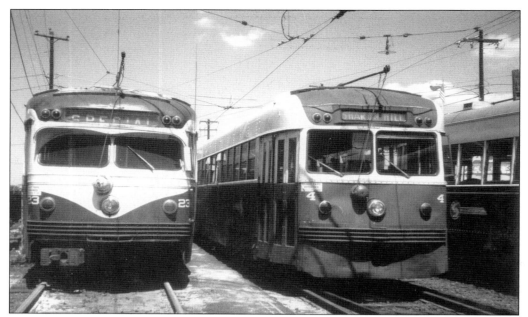

On the siding near the Sixty-ninth Street Terminal, car No. 23 (built by St. Louis Car Company) and car No. 4 (built by J. G. Brill Car Company) are awaiting their next assignment on May 30, 1970, on the Southeastern Pennsylvania Transportation Authority. Base service was operated by these cars, and the J. G. Brill Car Company 80 series cars handled peak periods. (Photograph by Kenneth C. Springirth.)

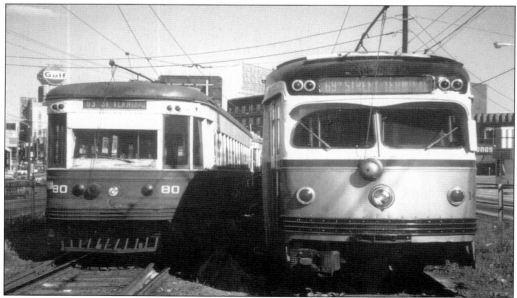

Car No. 80 in Philadelphia Suburban Transportation Company cream and Tuscan red colors and car No. 14 in the Southeastern Pennsylvania Transportation Authority cream and gold with red stripe colors are near the Sixty-ninth Street Terminal on May 30, 1970. Car No. 80 has been preserved at the Electric City Trolley Museum. Car No. 14 has been preserved at the Pennsylvania Trolley Museum. (Photograph by Kenneth C. Springirth.)

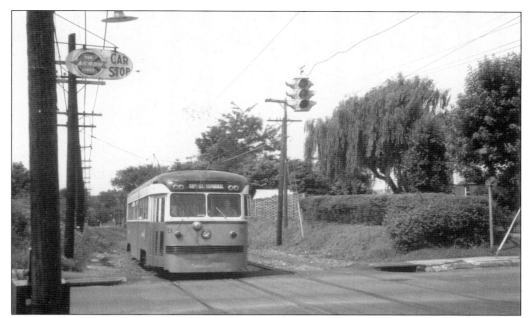

Southeastern Pennsylvania Transportation Company car No. 9 is at Leamy Avenue eastbound for the Sixty-ninth Street Terminal on July 13, 1970. In the early 1970s, the Media line between Drexelbrook and Scenic Road was double tracked, and double track was extended from Beatty Road to Providence Road. This car was acquired by the Electric City Trolley Museum at Scranton. (Photograph by Kenneth C. Springirth.)

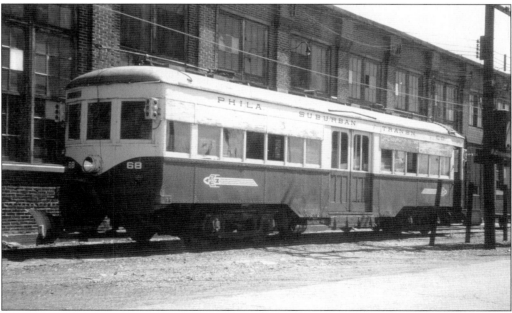

Center door car No. 68 is at Llanerch carbarn on April 17, 1971. This car was part of a 12-car order (Nos. 65–76) built by J. G. Brill Car Company in 1926. The center door design of this car permitted very rapid loading and unloading of passengers. (Photograph by Kenneth C. Springirth.)

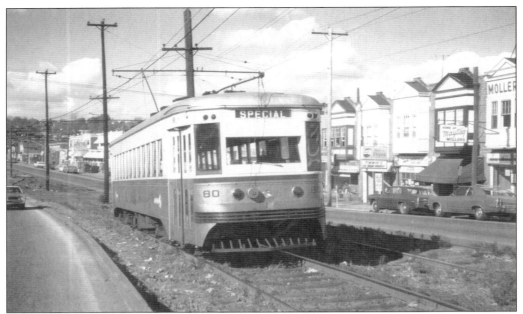

Car No. 80 sporting the new Southeastern Pennsylvania Transportation Authority gold bottom, cream top, and red stripe colors is eastbound on West Chester Pike near the Sixty-ninth Street Terminal on November 21, 1971. During December 1971, new shop facilities were opened for the Media and Sharon Hill trolley lines at the Sixty-ninth Street shops of the Market-Frankford Subway-Elevated Line. (Photograph by Kenneth C. Springirth.)

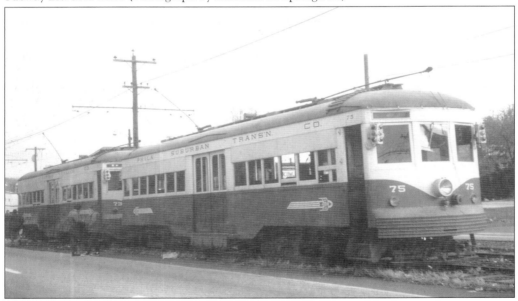

Center door car Nos. 73 and 75 are operating on West Chester Pike for a rail excursion on November 21, 1971. The Southeastern Pennsylvania Transportation Authority had retained four center door cars for emergency and charter service. Trackage on West Chester Pike was removed when the shops were moved from Llanerch to the Sixty-ninth Street Terminal. (Photograph by Kenneth C. Springirth.)

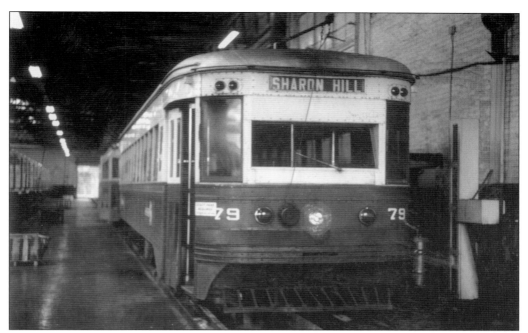

Brill master unit car No. 79 is at the Sixty-ninth Street shops of the Southeastern Pennsylvania Transportation Authority on May 20, 1972. The shops had been moved to this location from Llanerch for the five-foot, two-and-one-quarter-inch broad-gauge Media and Sharon Hill trolley lines. A separate shop facility handled the four-foot, eight-and-a-half-inch standard-gauge third rail Norristown line. (Photograph by Kenneth C. Springirth.)

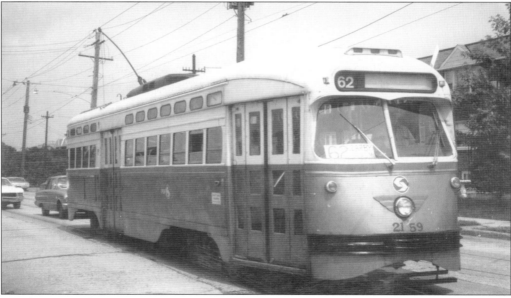

Presidents' Conference Committee car No. 2159 is at Chester Avenue and Cedar Avenue in the borough of Yeadon on route 62 for a rail excursion on June 25, 1972. This car is in a new Southeastern Pennsylvania Transportation Authority paint scheme with a white upper section, gold lower section, and a red stripe. (Photograph by Kenneth C. Springirth.)

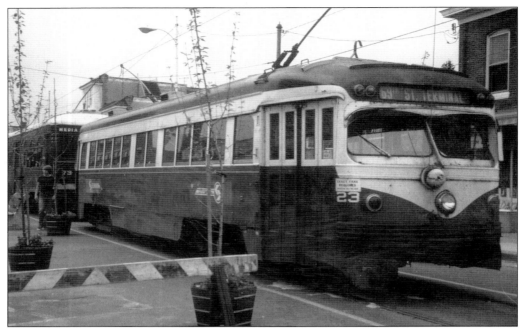

Southeastern Pennsylvania Transportation Authority car Nos. 23 and 73 are at State Street and Monroe Street in the borough of Media on June 24, 1972, during the Media Town Fair. Downtown Media merchants had set up the fair to promote shopping, and the street was closed to all traffic except trolleys and pedestrians. (Photograph by Kenneth C. Springirth.)

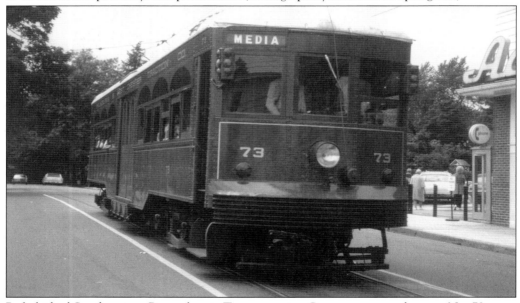

Refurbished Southeastern Pennsylvania Transportation Company center door car No. 73 poses on State Street and Orange Street at the end of the line in the borough of Media on June 24, 1972. Media, the county seat of Delaware County, was successful in keeping its downtown business area thriving by focusing on its unique trolley car connection to Philadelphia. (Photograph by Kenneth C. Springirth.)

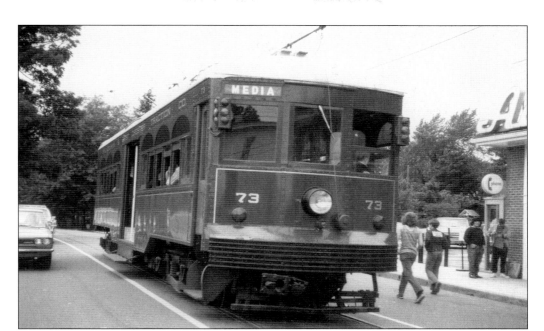

Center door car No. 73 is at the terminus at State Street just west of Orange Street in the borough of Media on June 24, 1972, during the Media Town Fair. There were 32 cars in this series built by J. G. Brill Car Company, with car Nos. 45–54 built in 1919. Car Nos. 55–64 were built in 1925. Car Nos. 65–76 were built in 1926. (Photograph by Kenneth C. Springirth.)

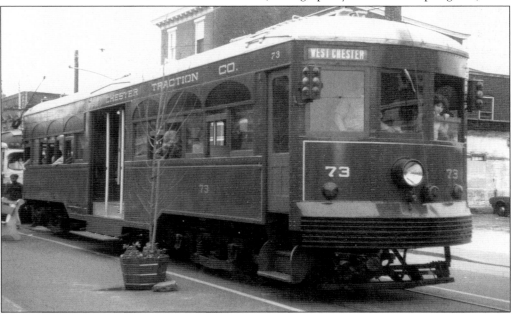

Southeastern Pennsylvania Transportation Authority car No. 73 is on State Street at Monroe Street in the borough of Media for the town fair on June 24, 1972. As suburban shopping malls attracted business, the trolley line provided a unique shopping experience for Media. Over the years, Media merchants recognized the importance of the trolley line that delivered customers to their stores. (Photograph by Kenneth C. Springirth.)

In the afternoon rush hour of April 10, 1974, Southeastern Pennsylvania Transportation Authority car No. 79 is leaving the Sixty-ninth Street Terminal running express to Drexel Hill Junction (Shadeland Avenue) and local stops to the Sharon Hill terminus. The car was repainted with an orange lower section, white upper section, blue stripe, and silver roof. (Photograph by Kenneth C. Springirth.)

Car No. 168 (original car No. 68) is at the Bryn Mawr station on the Norristown High Speed Line on April 10, 1974. This car, built by J. G. Brill Car Company in 1929, was retired on August 23, 1986, and was sold to the Keokuk Junction Railway and later sold to the New York Museum of Transportation at West Henrietta, New York. (Photograph by Kenneth C. Springirth.)

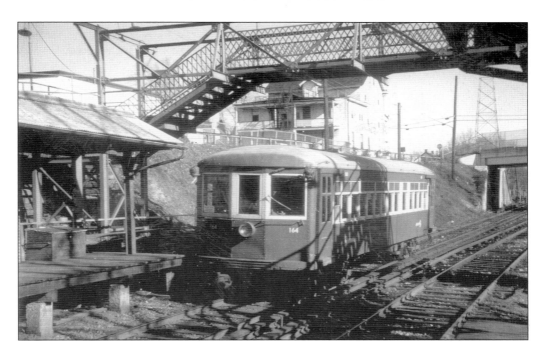

On April 10, 1974, Southeastern Pennsylvania Transportation Authority car No. 164 (original car No. 64), built by J. G. Brill Car Company in 1927, is at the Bryn Mawr station. These cars were built for the Strafford line and later handled Norristown line rush-hour runs. This car was retired on August 23, 1986, and was acquired by the East Troy Electric Railroad Museum at East Troy, Wisconsin. (Photograph by Kenneth C. Springirth.)

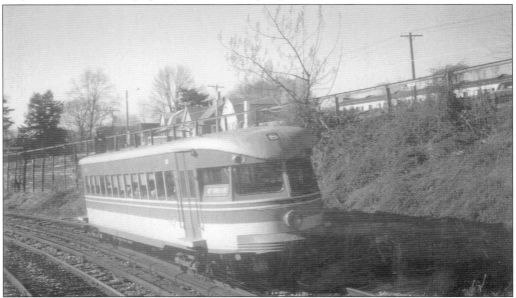

Bullet car No. 208, built by J. G. Brill Car Company in 1931, is near the Bryn Mawr station on April 10, 1974. The Southeastern Pennsylvania Transportation Authority had applied a new paint scheme on this car with an orange and off-white body, pink stripe below the windows, and silver roof. (Photograph by Kenneth C. Springirth.)

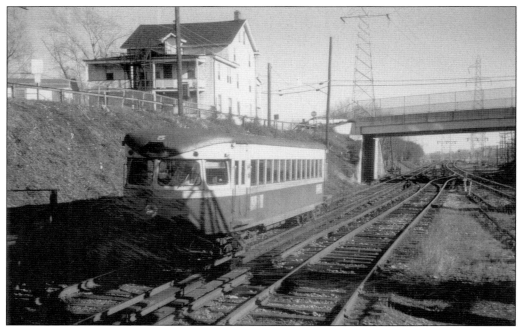

Southeastern Pennsylvania Transportation Authority car No. 205 is at the Bryn Mawr station on April 10, 1974. This 1931 product of J. G. Brill Car Company helped the former Philadelphia and Western Railway survive the Depression. Cars of this series were retired in 1990. In 2007, this car at the Rockhill Trolley Museum at Rockhill Furnace is the only Bullet car operating anywhere in the world. (Photograph by Kenneth C. Springirth.)

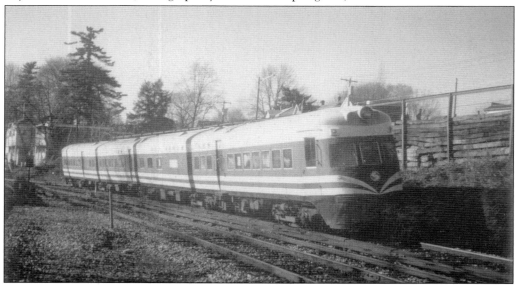

A Liberty Liner passes the Bryn Mawr station on April 10, 1974. When placed in service by the Philadelphia Suburban Transportation Company, these cars were popular. As operating costs mounted, they were discontinued by the Southeastern Pennsylvania Transportation Authority. One Liberty Liner is preserved at Rockhill Trolley Museum at Rockhill Furnace and the other at the Illinois Railway Museum at Union, Illinois. (Photograph by Kenneth C. Springirth.)

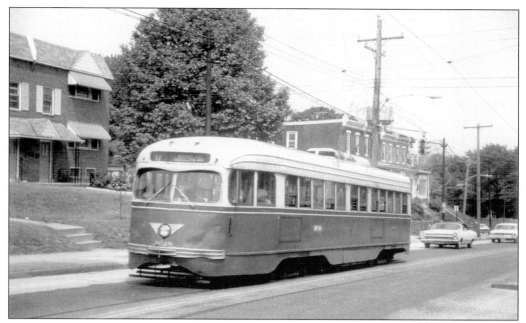

Southeastern Pennsylvania Transportation Authority route 11 Presidents' Conference Committee car No. 2068 is on Main Street just past Front Street westbound for the Darby terminal on May 24, 1975. This car was delivered during March 1941 by St. Louis Car Company and was destroyed in the Woodland Depot fire of October 23, 1975. (Photograph by Kenneth C. Springirth.)

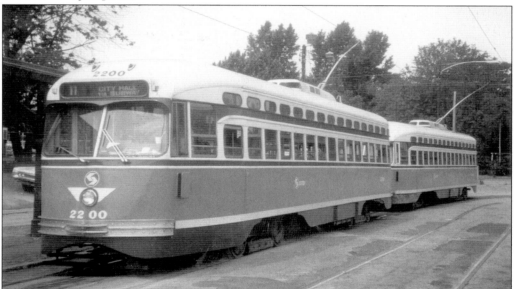

Presidents' Conference Committee car No. 2200 is on a layover at Darby Loop on May 24, 1975. The Southeastern Pennsylvania Transportation Authority adopted a new paint scheme with an orange lower section, white roof and windows, and blue trim. This car was delivered by St. Louis Car Company during July 1948 and was destroyed in the Woodland Depot fire of October 23, 1975. (Photograph by Kenneth C. Springirth.)

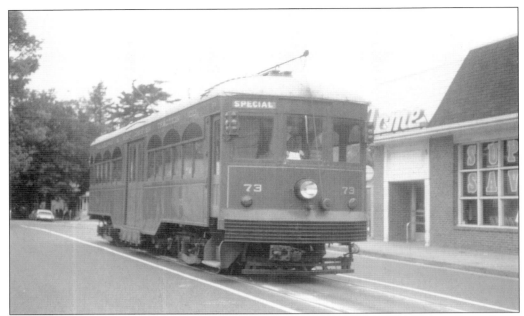

Southeastern Pennsylvania Transportation Authority center door car No. 73 is at State Street just past Orange Street in the borough of Media on a rail excursion conducted on May 25, 1975. While this car was popular with students of transportation, it played an important role with various events in the Media business district. (Photograph by Kenneth C. Springirth.)

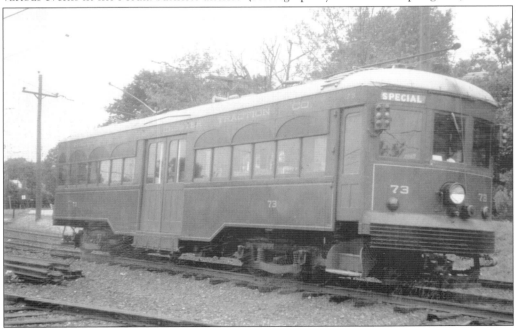

On May 25, 1975, center door car No. 73 is eastbound on the Media Division at Drexel Hill Junction, which is where the Media and Sharon Hill lines come together. The Southeastern Pennsylvania Transportation Authority had restored the car to its original condition as close as possible during June 1972. (Photograph by Kenneth C. Springirth.)

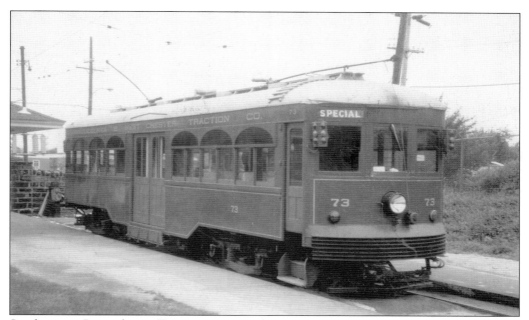

Southeastern Pennsylvania Transportation Authority car No. 73 is at the terminus of the Sharon Hill line on May 25, 1975. Opening on August 1, 1917, Sharon Hill was the last trolley line completed by the Philadelphia and West Chester Traction Company. Just south of the terminus was Chester Pike, once served by the Darby–Chester trolley line of the Southern Pennsylvania Traction Company. (Photograph by Kenneth C. Springirth.)

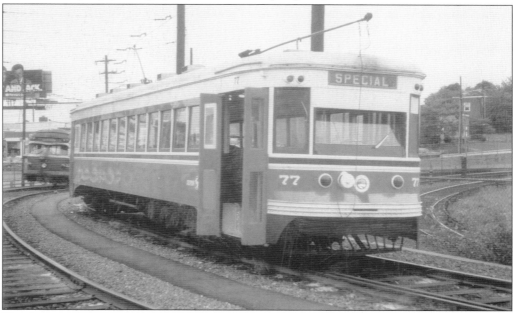

The Sixty-ninth Street Terminal on May 25, 1975, finds car No. 77 waiting for the next assignment. The Southeastern Pennsylvania Transportation Authority's new paint scheme with orange bottom, white upper section, silver roof, and blue trim resulted in an attractive trolley that was dramatically different from its former Tuscan red appearance. (Photograph by Kenneth C. Springirth.)

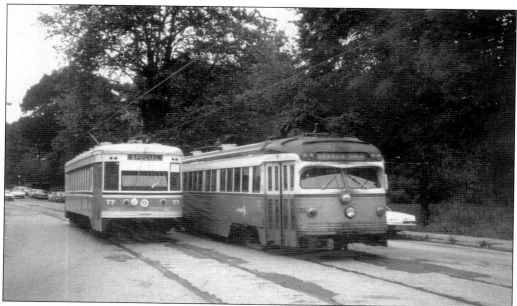

J. G. Brill Car Company–built car No. 77, painted orange, white, blue, and silver, is passing St. Louis Car Company–built car No. 15, painted gold, cream, and black, with a red stripe, on Woodland Avenue in the borough of Aldan on May 25, 1975. The Southeastern Pennsylvania Transportation Authority had experimented with various paint schemes to improve the visual look of the trolleys. (Photograph by Kenneth C. Springirth.)

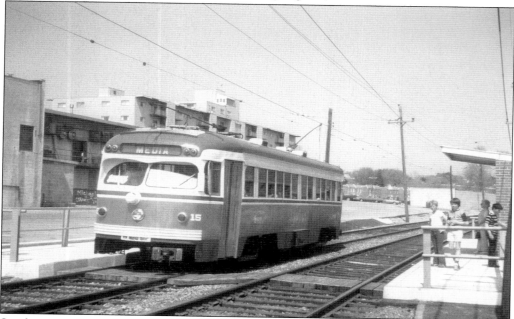

Southeastern Pennsylvania Transportation Authority car No. 15 is westbound on the Media line at the Drexeline station during April 1976. This car was 27 years old when it received the new orange bottom, white window section, blue roof, and blue trim paint scheme representing a dramatic change from the original Tuscan red. (Photograph by Kenneth C. Springirth.)

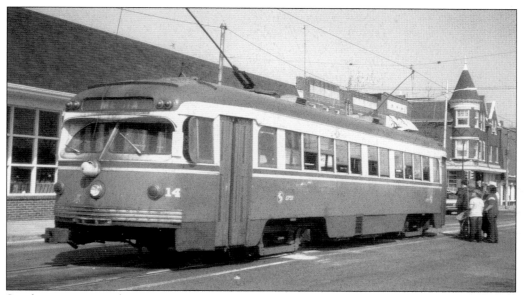

Southeastern Pennsylvania Transportation Authority car No. 14 is at the terminus of the Media line at State Street just west of Orange Street during April 1976. After the operator completed changing ends, which involved raising one pole up and lowering one pole down, the passengers boarded the car for the eastbound trip to the Sixty-ninth Street Terminal. (Photograph by Kenneth C. Springirth.)

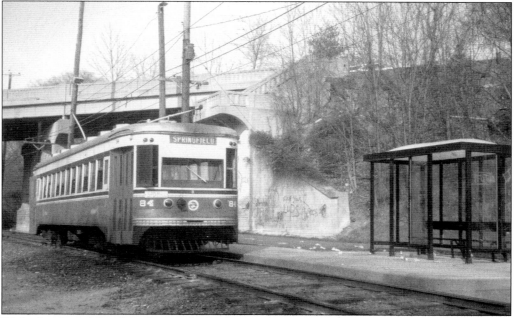

With the Sproul Road Bridge in the background, Southeastern Pennsylvania Transportation Authority car No. 84 is at the Springfield Mall station on the Media line during April 1976. The Springfield Mall sign meant that the operator changed ends here and headed back to the Sixty-ninth Street Terminal. This car was acquired by the Shore Line Trolley Museum at East Haven, Connecticut. (Photograph by Kenneth C. Springirth.)

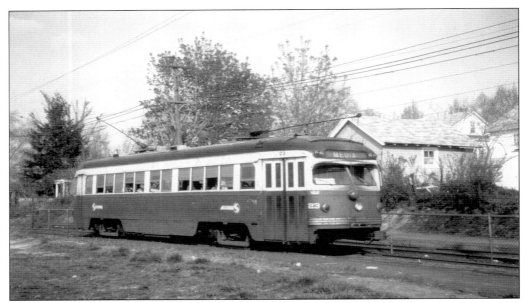

Southeastern Pennsylvania Transportation Authority car No. 23 is approaching Leamy Avenue in Springfield Township during April 1976 on a westbound trip to the borough of Media. When the eight-and-a-half-mile Media line opened on April 1, 1913, most the area was rural except for the villages of Aronimink and Springfield. (Photograph by Kenneth C. Springirth.)

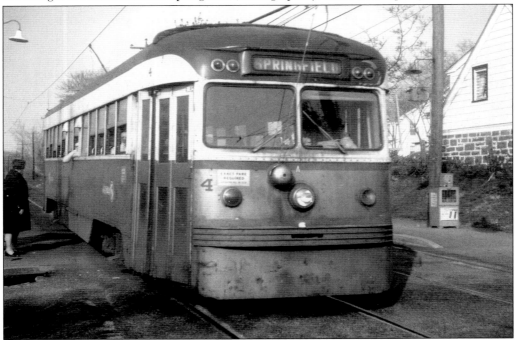

Westbound for Woodland Avenue in Springfield Township, Southeastern Pennsylvania Transportation Authority car No. 4 is crossing Leamy Avenue during the afternoon rush hour of April 1976. This J. G. Brill Car Company car built in 1941 was 35 years old when this picture was taken but was still in everyday service. (Photograph by Kenneth C. Springirth.)

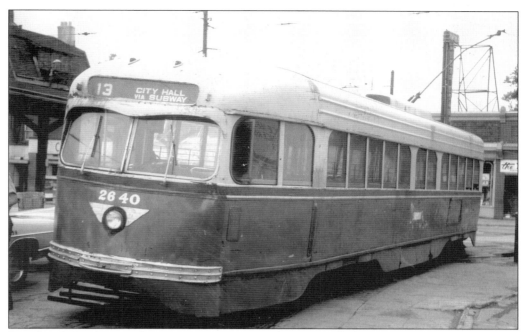

Presidents' Conference Committee car No. 2640 has just pulled into Darby Loop on May 30, 1976, on route 13. This trolley was delivered to the Philadelphia Transportation Company during July 1942 and was scrapped by the Southeastern Pennsylvania Transportation Authority during March 1982. Most route 13 trolleys terminated at Yeadon Loop, with certain trips continuing to Darby Loop. (Photograph by Kenneth C. Springirth.)

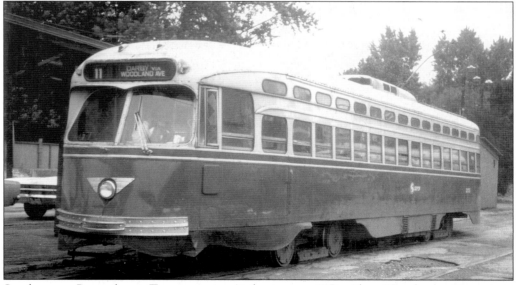

Southeastern Pennsylvania Transportation Authority route 11 Presidents' Conference Committee car No. 2175 is at Darby Loop on May 30, 1976. Philadelphia Transportation Company received this car from St. Louis Car Company during July 1948. This car was sold to Brookville Equipment Corporation for parts during 2004. Routes 11 and 13 shared the Darby terminal. (Photograph by Kenneth C. Springirth.)

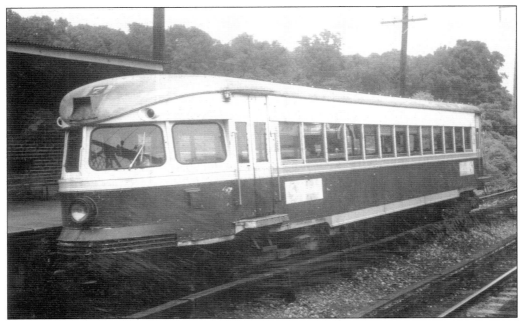

Bullet car No. 207 is at the Radnor station on the Southeastern Pennsylvania Transportation Authority's Norristown line on July 23, 1976. This car was badly damaged in a collision with car No. 202. It was retired on January 26, 1987, and was sold to the Seashore Trolley Museum for parts. (Photograph by Kenneth C. Springirth.)

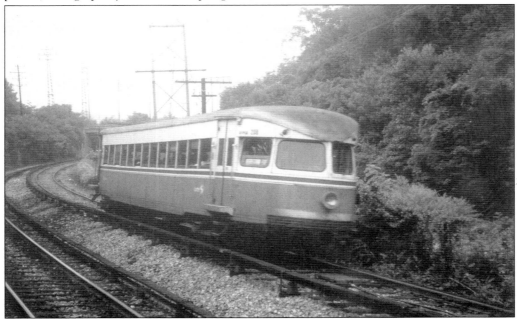

On July 23, 1976, Southeastern Pennsylvania Transportation Authority car No. 208 is near the Radnor station on the Norristown High Speed Line. This car was retired during December 1989 after being trucked to Woodland Depot for evaluation and was later sold to the Seashore Trolley Museum at Kennebunkport, Maine. (Photograph by Kenneth C. Springirth.)

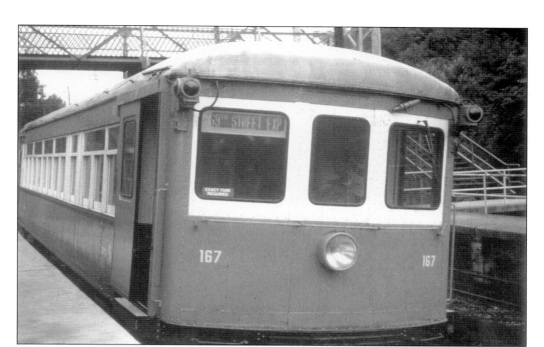

The Radnor station finds Southeastern Pennsylvania Transportation Authority car No. 167 (original car No. 67) heading for the Sixty-ninth Street Terminal on July 23, 1976. This car, built by J. G. Brill Car Company in 1929, was destroyed in a collision at the Sixty-ninth Street Terminal and was retired on August 23, 1986. (Photograph by Kenneth C. Springirth.)

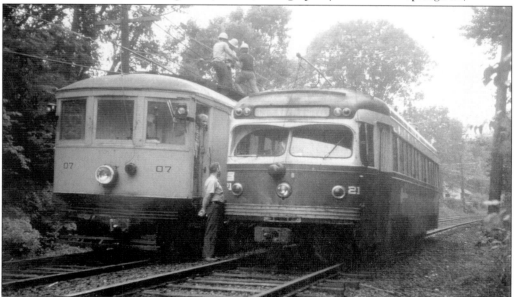

The Southeastern Pennsylvania Transportation Authority work crew is on line car No. 07 making overhead wire repairs near Springfield Road on the Media line with car No. 21 waiting to proceed on July 23, 1976. Car No. 07 was acquired by the Pennsylvania Trolley Museum at Washington, Pennsylvania. Car No. 21 was acquired by the Shore Line Trolley Museum at East Haven, Connecticut. (Photograph by Kenneth C. Springirth.)

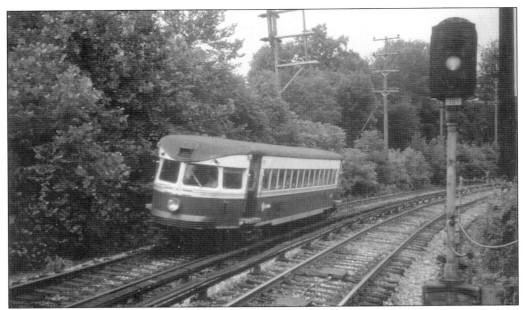

A Southeastern Pennsylvania Transportation Authority Bullet car is passing by the Radnor station on July 23, 1976, on the Norristown High Speed Line. This has been a unique line with high-level platforms and third rail contact typical of a heavy rail system, onboard fare collection found on a trolley line, and a suburban setting like a commuter rail line. (Photograph by Kenneth C. Springirth.)

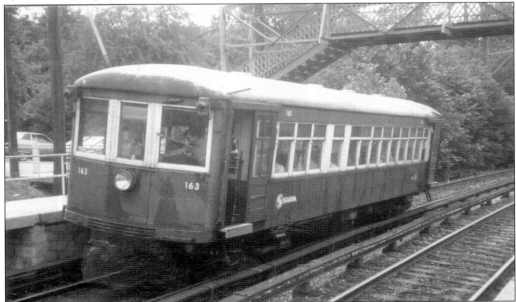

Norristown High Speed Line car No. 163 (original number 63) is at the Radnor station on July 23, 1976. The Southeastern Pennsylvania Transportation Authority assigned route 100 to this line, but riders call it the P&W because of its heritage as the Philadelphia and Western Railway. This car, retired on March 24, 1988, has been rebuilt as a gas mechanical car at Mount Dora, Florida. (Photograph by Kenneth C. Springirth.)

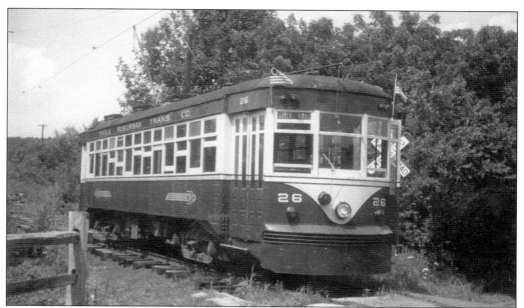

The Buckingham Valley Trolley Association, using New Hope and Ivyland Railroad trackage in this July 24, 1976, scene, operates car No. 26. This was originally car No. 4024 purchased from the Philadelphia Transportation Company during 1942 by the Philadelphia Suburban Transportation Company. J. G. Brill Car Company built the car during 1918. Electric City Trolley Museum at Scranton now has this car. (Photograph by Kenneth C. Springirth.)

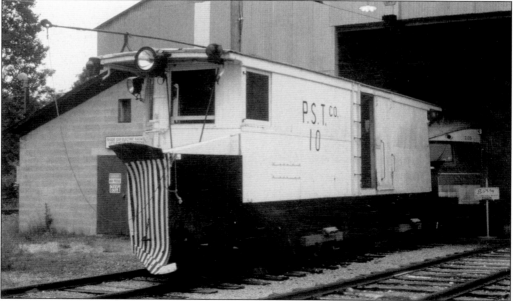

Former Philadelphia and Western Railway snowplow No. 10 is at the Rockhill Trolley Museum in the borough of Rockhill Furnace in Huntingdon County on June 22, 1996. The Wason Car Company built this car during 1915. A number of Philadelphia trolleys have been preserved at this museum where the trolleys meet the steam trains of the East Broad Top Railroad. (Photograph by Kenneth C. Springirth.)

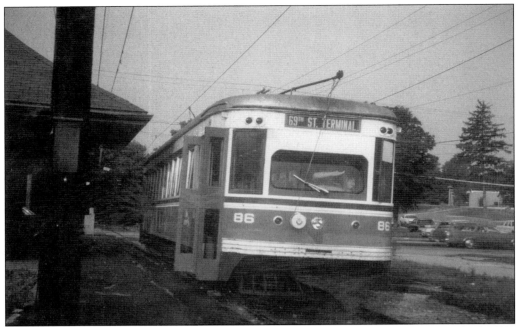

Car No. 86 is at Woodland Avenue in Springfield Township on the Media line on July 5, 1977. During rush hours the Southeastern Pennsylvania Transportation Authority operated a number of trips from the Sixty-ninth Street Terminal to Springfield to handle the ridership on the busiest section of the Media line. (Photograph by Kenneth C. Springirth.)

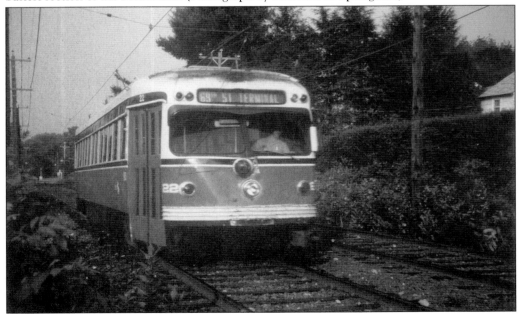

Southeastern Pennsylvania Transportation Authority car No. 22 is eastbound for the Sixty-ninth Street Terminal on the Media line about to cross Leamy Avenue in Springfield Township on July 5, 1977. This car sparkled in the afternoon sunshine in its orange bottom, white upper section, and blue trim paint scheme. (Photograph by Kenneth C. Springirth.)

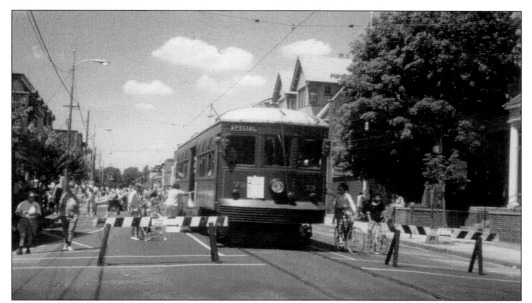

One of the main attractions of the Media Town Fair is center door trolley car No. 73 at State and Jackson Streets in the borough of Media on July 28, 1977. According to the July 27, 1977, *Town Talk* newspaper, this was the "Media Merchants 14th Annual Sidewalk Sale." State Street was closed to all traffic except for pedestrians and the trolley. (Photograph by Kenneth C. Springirth.)

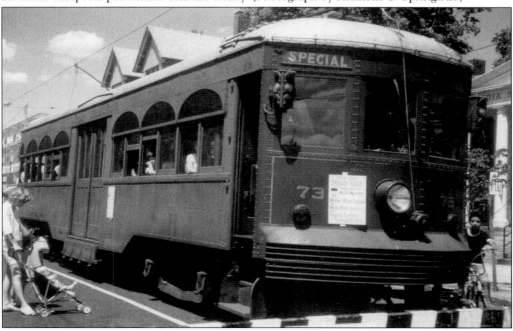

Merchants set up their sidewalk sale, which attracted shoppers to the borough of Media in this July 28, 1977, scene with car No. 73 at State and Jackson Streets. The July 27, 1977, *Town Talk* newspaper noted, "Rides will cost 10 cents this year (free to senior citizens)," with Media Office Supply and Media Area Jaycees underwriting the remaining cost for the trolley. (Photograph by Kenneth C. Springirth.)

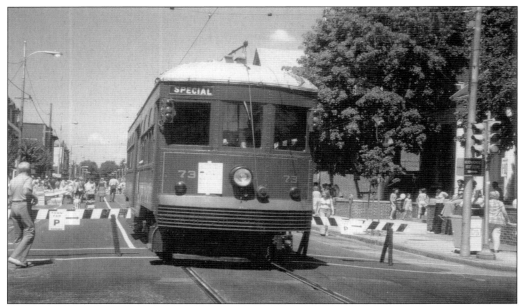

On July 28, 1977, center door car No. 73 is at State and Jackson Streets for the Media Town Fair. State Street in the borough of Media was closed to traffic except for the trolley car and pedestrians from Monroe Street to Orange Street. Community groups had displays and demonstrations. Merchants had a sidewalk sale, and there was live musical entertainment. (Photograph by Kenneth C. Springirth.)

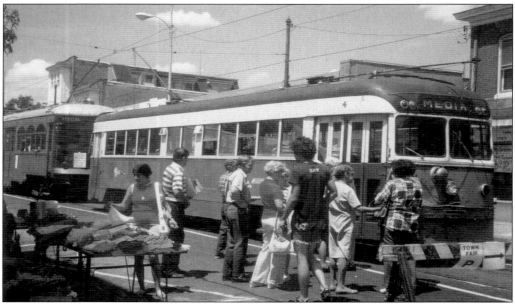

Southeastern Pennsylvania Transportation Authority car No. 4 is at State and Monroe Streets on July 28, 1977, preparing to load passengers for the eastbound trip to the Sixty-ninth Street Terminal, and car No. 73 is operating as a shuttle from Monroe Street to Orange Street during the Media Town Fair. The fair was held from Thursday July 28, 1977, to Sunday July 30, 1977. (Photograph by Kenneth C. Springirth.)

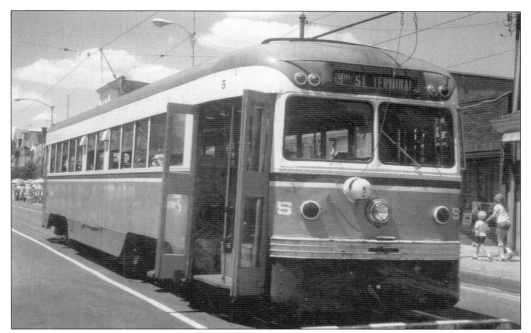

State and Monroe Streets in the borough of Media find car No. 5 awaiting departure time for the Sixty-ninth Street Terminal on July 28, 1977. During the Media Town Fair, trolley car No. 73 operated on State Street from Orange Street to Monroe Street where passengers for the Sixty-ninth Street Terminal could transfer to a regular service trolley. In 1982, the Pennsylvania Trolley Museum acquired this car. (Photograph by Kenneth C. Springirth.)

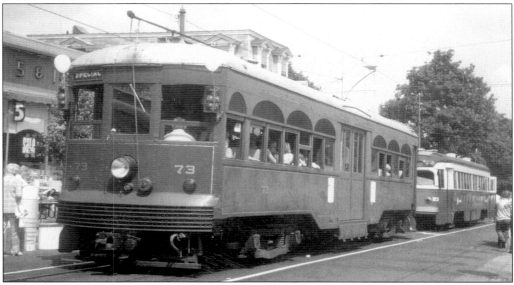

Southeastern Pennsylvania Transportation Authority car No. 73 is at State and Monroe Streets in the borough of Media where car No. 23 is loading passengers for the trip to the Sixty-ninth Street Terminal on July 30, 1977. Merchants and health, civic, and governmental organizations set up displays on State Street from Monroe Street to Orange Street during the Media Town Fair. (Photograph by Kenneth C. Springirth.)

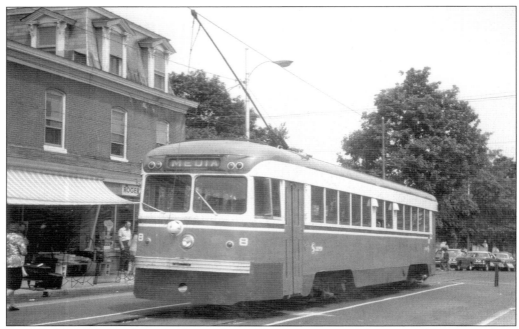

On July 30, 1977, Southeastern Pennsylvania Transportation Authority car No. 8 is at State and Monroe Streets in the borough of Media preparing for departure for the Sixty-ninth Street Terminal. Business, social, and governmental groups provided exhibits along State Street for the Media Town Fair. This trolley has been preserved at the Shore Line Trolley Museum at East Haven, Connecticut. (Photograph by Kenneth C. Springirth.)

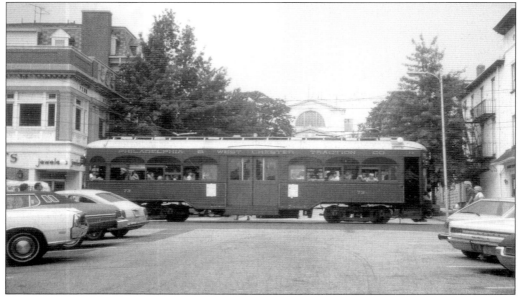

Center door car No. 73 is eastbound on State Street crossing South Avenue with the Delaware County Courthouse behind the trolley on July 30, 1977. The trolley ferried passengers along State Street from Orange Street to Monroe Street, adding a distinctive quality of life to this picturesque community. (Photograph by Kenneth C. Springirth.)

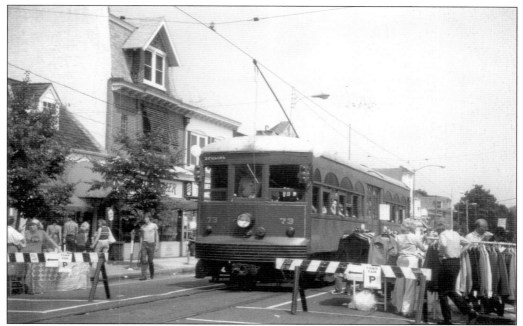

Southeastern Pennsylvania Transportation Authority center door car No. 73 is cruising along State Street in the borough of Media on July 30, 1977. At the Media Town Fair there were informational exhibits, and merchants adorned State Street with tables displaying a variety of items. This was an educational, fun-filled event that showcased the community. (Photograph by Kenneth C. Springirth.)

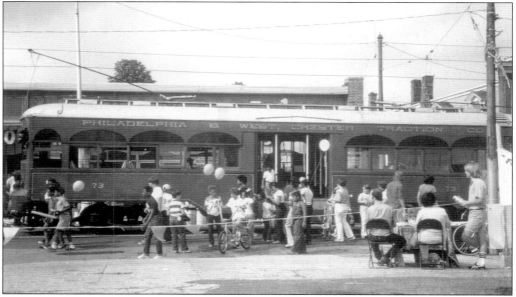

Adults and children of all ages are enjoying their ride on car No. 73 on July 30, 1977, at the Media Town Fair. Media businesses worked hard to meet the competition of nearby shopping districts, and the trolley car was a factor in their promotional activities. Many of the stores displayed a picture of the trolley in their windows. (Photograph by Kenneth C. Springirth.)

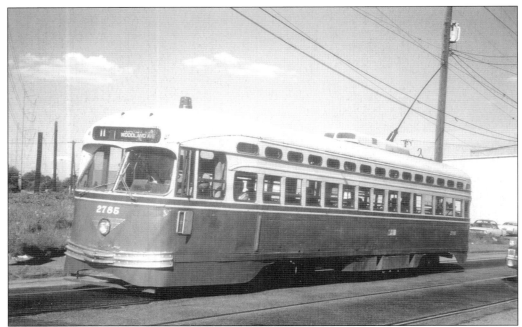

Presidents' Conference Committee Car No. 2785 is on Main Street near the crossing of the Baltimore and Ohio Railroad in the borough of Darby on July 17, 1978. St. Louis Car Company delivered this car to the Philadelphia Transportation Company during April 1947. This car was used on the Chestnut Hill trolley line and was in dead storage at Elmwood Depot on October 15, 2006. (Photograph by Kenneth C. Springirth.)

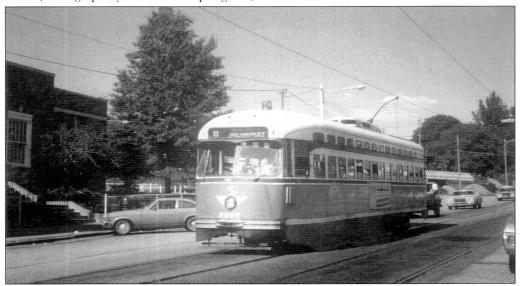

Southeastern Pennsylvania Transportation Authority route 11 Presidents' Conference Committee car No. 2099 is westbound on Main Street at Ridge Avenue in the borough of Darby on July 17, 1978. The Philadelphia Transportation Company received this car from St. Louis Car Company during August 1948. It was sold to the San Francisco Municipal Railway and went into service during 1995 as car No. 1059. (Photograph by Kenneth C. Springirth.)

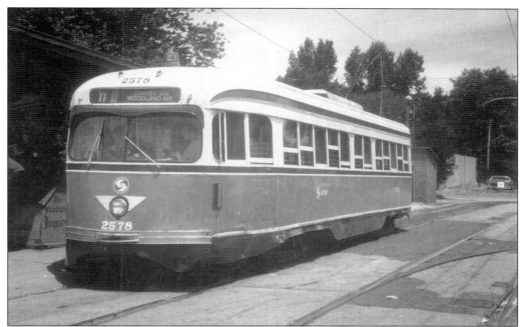

On July 22, 1978, route 11 Presidents' Conference Committee car No. 2578 is at Darby Loop awaiting departure time for the trip to Center City Philadelphia. The Philadelphia Transportation Company received this car from St. Louis Car Company during January 1941. The Southeastern Pennsylvania Transportation Authority scrapped this car during 1982. (Photograph by Kenneth C. Springirth.)

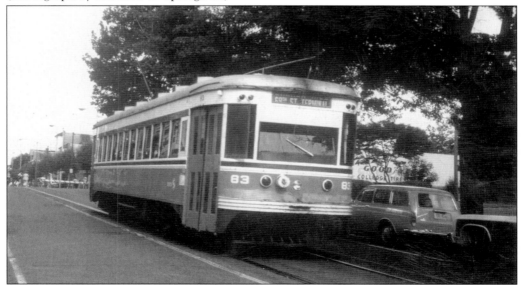

Southeastern Pennsylvania Transportation Authority car No. 83 is on State Street in the borough of Media on July 27, 1979, eastbound for the Sixty-ninth Street Terminal. The trolley car has continued to bring people into the Media business district as well as providing a convenient connection to the Market-Frankford Subway-Elevated Line for Center City Philadelphia. (Photograph by Kenneth C. Springirth.)

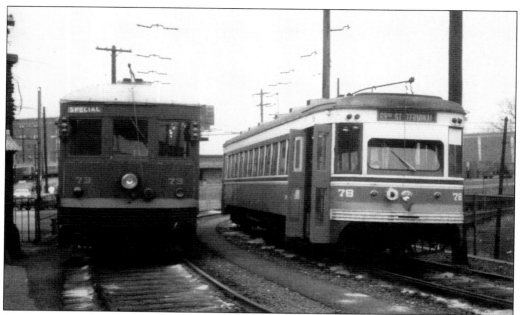

Two J. G. Brill Car Company–built trolleys are at the Sixty-ninth Street Terminal on November 24, 1979. Car No. 73, built in 1926, was a giant weighing 52,280 pounds, while car No. 78, built in 1931, represented a lightweight car weighing 41,980 pounds. Both cars have been preserved at the Pennsylvania Trolley Museum in Washington, Pennsylvania. (Photograph by Kenneth C. Springirth.)

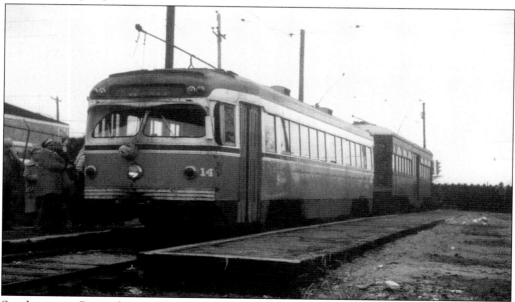

Southeastern Pennsylvania Transportation Authority car No. 14, built by St. Louis Car Company in 1949, is loading passengers at the Sharon Hill station, and behind it is center door car No. 73 on a rail enthusiast excursion on November 24, 1979. Both of these trolleys have been preserved at the Pennsylvania Trolley Museum in Washington, Pennsylvania. (Photograph by Kenneth C. Springirth.)

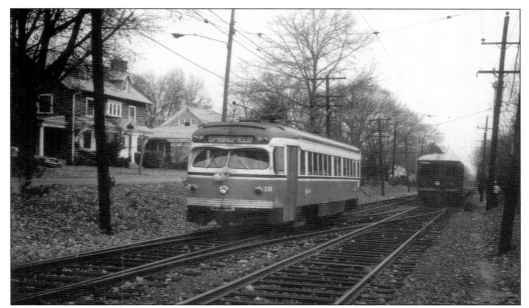

Car No. 18 has just past center door car No. 73 approaching Shadeland Avenue at Drexel Hill Junction on November 24, 1979. This trolley line on its own private right-of-way has channeled passengers along a definite transportation corridor that has had a positive impact on the development of Delaware County. Shore Line Trolley Museum at East Haven, Connecticut, acquired car No. 18. (Photograph by Kenneth C. Springirth.)

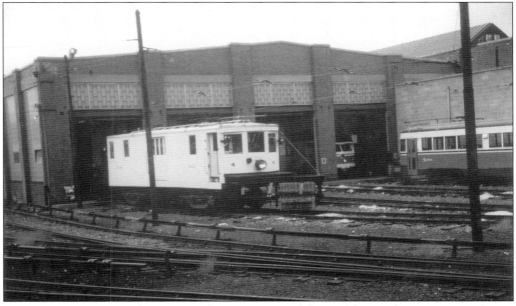

Snow sweeper No. 4 is at the Sixty-ninth Street Terminal shops of the Southeastern Pennsylvania Transportation Authority on November 24, 1979. Built by the McGuire Cummings Company in 1922 for the Philadelphia Suburban Transportation Company, this car was acquired by the Pennsylvania Trolley Museum in Washington, Pennsylvania, during 1988. (Photograph by Kenneth C. Springirth.)

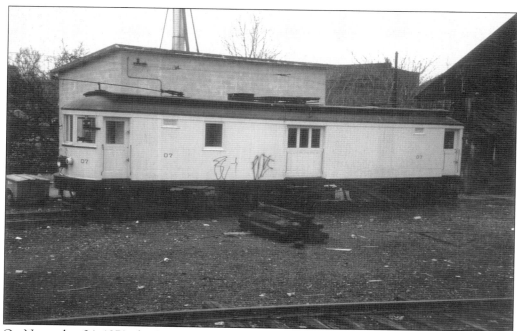

On November 24, 1979, the Southeastern Pennsylvania Transportation Authority's Sixty-ninth Street shops are the setting for line car No. 07, which was equipped with a roof platform for working on the overhead system. This car was 68 years old when this picture was taken. The car is now preserved at the Pennsylvania Trolley Museum at Washington, Pennsylvania. (Photograph by Kenneth C. Springirth.)

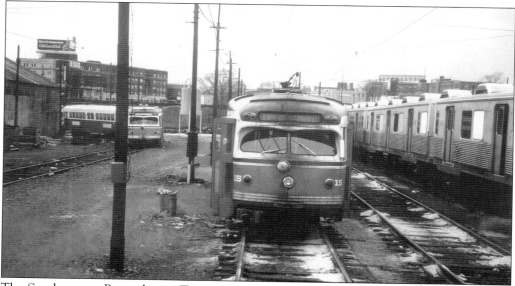

The Southeastern Pennsylvania Transportation Authority's Sixty-ninth Street shops find car No. 15 with Market-Frankford Subway-Elevated Line cars on the right and car No. 11 behind on the left on November 24, 1979. The Market-Frankford Subway-Elevated Line from Fifteenth Street through West Philadelphia opened to the Sixty-ninth Street Terminal on March 4, 1907. Trolleys began using the terminal on April 30, 1907. (Photograph by Kenneth C. Springirth.)

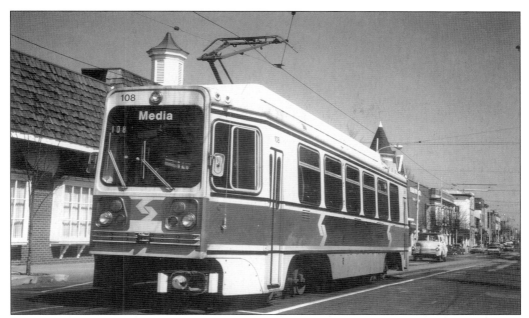

The terminus of the Media line at State Street just west of Orange Street is the setting for Southeastern Pennsylvania Transportation Authority car No. 108 on April 10, 1982. Built by Kawasaki Heavy Industries of Kobe, Japan, and delivered on August 27, 1981, this pantograph-equipped car was powered by four Westinghouse model 1464 motors. The car weighed 60,043 pounds and seated 50 passengers. (Photograph by Kenneth C. Springirth.)

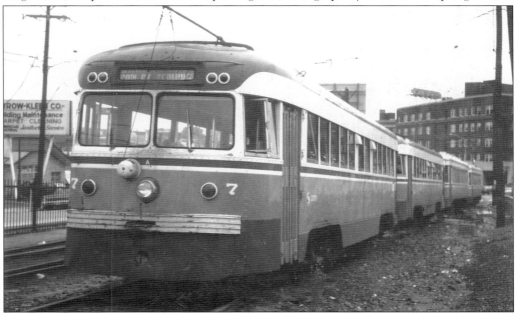

On May 29, 1982, car No. 7 is in the lineup of cars along the siding at West Chester Pike near the Sixth-ninth Street Terminal. This was one of the last traditional trolleys to run on the Media and Sharon Hill lines before replacement by the new light-rail vehicles in 1982. The car was acquired by the Electric City Trolley Museum at Scranton. (Photograph by Kenneth C. Springirth.)

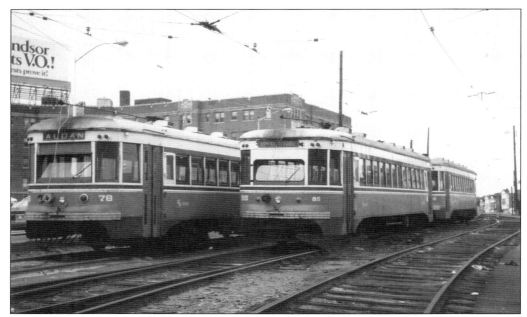

On May 29, 1982, J. G. Brill Car Company master unit car Nos. 78 and 85 are on the siding along West Chester Pike near the Sixty-ninth Street Terminal waiting for their next assignment. Car No. 78 was acquired by the Pennsylvania Trolley Museum during 1982. Car No. 85 was acquired by the Electric City Trolley Museum during 1982. (Photograph by Kenneth C. Springirth.)

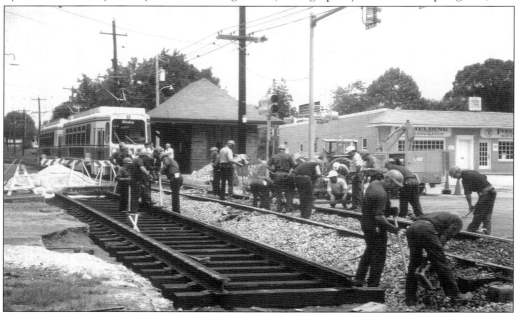

Car No. 111 is one of two new Kawasaki Heavy Industries light-rail vehicles at the Woodland station in Springfield Township on May 29, 1982. A new second track was installed for eventual double tracking of the Media line from Woodland Avenue to Interstate 476. As of February 2007, that double track has not yet been installed, but the second track is still in place on Woodland Avenue. (Photograph by Kenneth C. Springirth.)

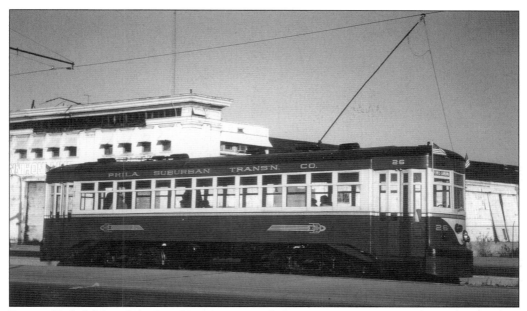

Former Philadelphia Suburban Transportation Company car No. 26 is at the Penns Landing Trolley Museum on Delaware Avenue in Philadelphia on November 7, 1982. This was one of three cars purchased from the Philadelphia Transportation Company during 1942 and numbered 20–22 but later renumbered 25–27. This car is now at the Electric City Trolley Museum at Scranton. (Photograph by Kenneth C. Springirth.)

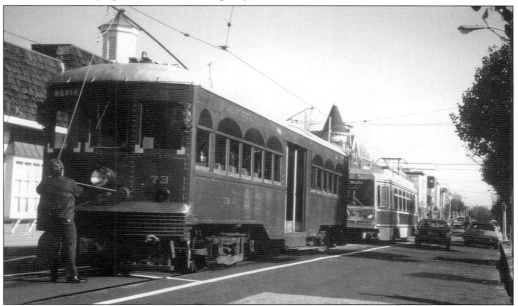

On November 7, 1982, center door car No. 73, on a rail enthusiast excursion, is at the end of the Media line on State Street just west of Orange Street with a new Kawasaki Heavy Industries light-rail vehicle behind it. The Southeastern Pennsylvania Transportation Authority had restored car No. 73 during 1972. It was acquired by the Pennsylvania Trolley Museum during 1990. (Photograph by Kenneth C. Springirth.)

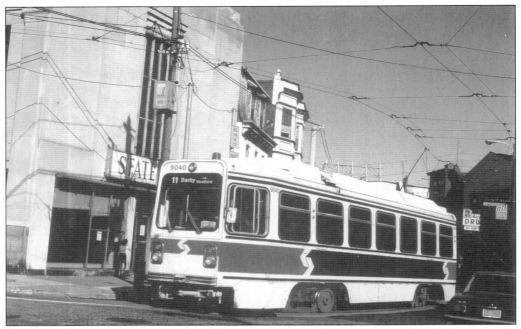

Kawasaki Heavy Industries car No. 9040 is turning from Main Street to Ninth Street in the borough of Darby on May 25, 1984. This was one of 112 new light-rail vehicles, numbered 9000–9111, purchased during 1980–1982, each costing $486,000 for subway surface routes 10, 11, 13, 34, and 36. Each car seated 50 and had a maximum speed of 50 miles per hour. (Photograph by Kenneth C. Springirth.)

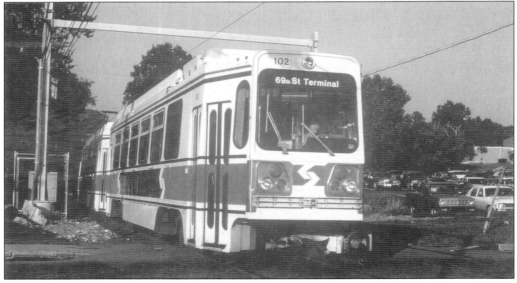

Eastbound for the Sixty-ninth Street Terminal, Southeastern Pennsylvania Transportation Authority car No. 102, heading a two-car train, is crossing Woodland Avenue in Springfield Township on August 8, 1984. This car delivered on September 17, 1982, by Kawasaki Heavy Industries was one of 29 cars numbered 100–128 for the Media and Sharon Hill trolley lines and had a maximum speed of 62 miles per hour. (Photograph by Kenneth C. Springirth.)

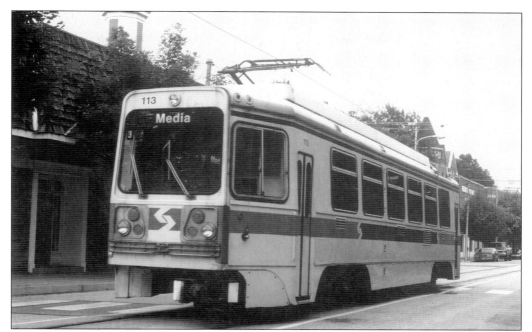

Kawasaki Heavy Industries car No. 113, delivered on August 4, 1982, is at the terminus of the Media line at State Street west of Orange Street on July 12, 1992. On November 4, 1980, car No. 100 was the first Kawasaki Heavy Industries car placed into revenue service on the Media line. The final Kawasaki Heavy Industries car No. 104 was delivered on December 4, 1982. (Photograph by Kenneth C. Springirth.)

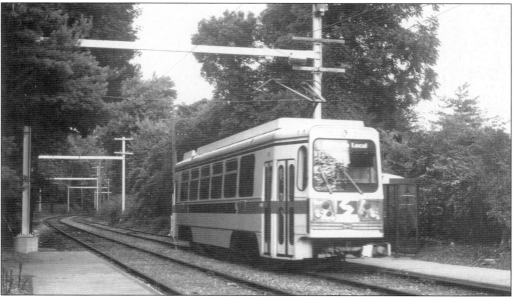

Southeastern Pennsylvania Transportation Authority car No. 126 is at Beatty Road on the Media line on July 12, 1992. This double-end car delivered by Kawasaki Heavy Industries on September 3, 1982, was 53 feet long, 8 feet 10 inches wide, and featured an automatic air-conditioning and heating system. (Photograph by Kenneth C. Springirth.)

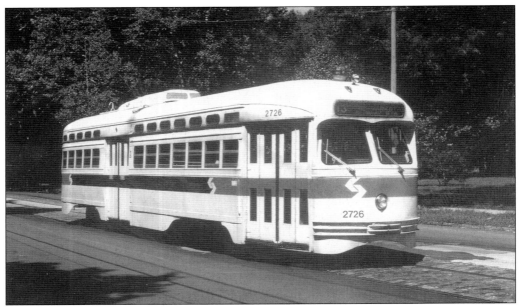

Presidents' Conference Committee car No. 2726 is at Forty-third Street and Chester Avenue passing by Clark Park on August 7, 1994. During 1850 to 1930, the area changed from a fashionable rural area to a middle-class trolley car suburb. The trolley car reduced travel time to Center City Philadelphia, which attracted new housing developments. Trolley routes were extended to Chester and Media. (Photograph by Kenneth C. Springirth.)

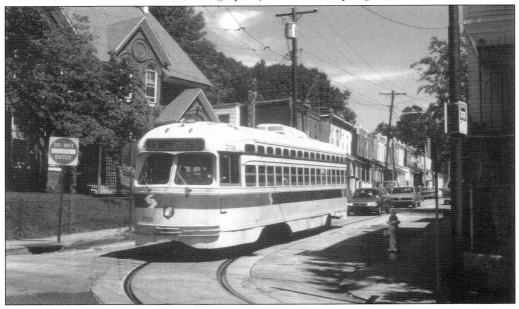

Passing the historic Darby Free Library, Presidents' Conference Committee car No. 2726 is on Tenth Street ready to turn onto Main Street in the borough of Darby on August 7, 1994. St. Louis Car Company delivered this car to the Philadelphia Transportation Company during March 1947. The Southeastern Pennsylvania Transportation Authority gave it a general overhaul during April 1987. (Photograph by Kenneth C. Springirth.)

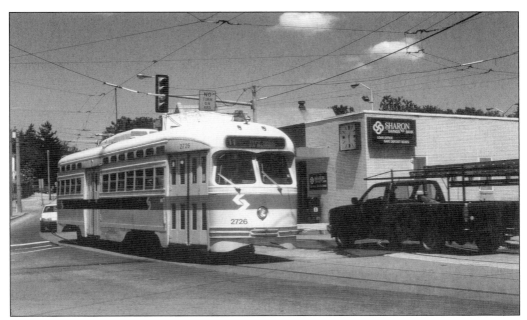

Presidents' Conference Committee car No. 2726 is on Main Street at Ninth Street in the borough of Darby on August 7, 1994. On September 23, 2002, this car departed for Brookville Equipment Corporation for rebuilding. The car was delivered to the Southeastern Pennsylvania Transportation Authority as No. 2328 on May 27, 2004, with new motors, electronic chopper control, air-conditioning, a wheelchair lift, and disc brakes. (Photograph by Kenneth C. Springirth.)

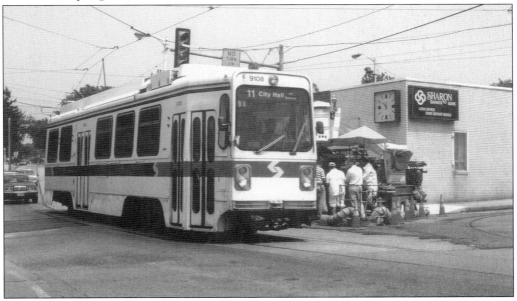

Southeastern Pennsylvania Transportation Authority route 11 Kawasaki Heavy Industries–built car No. 9108 is on Main Street at Ninth Street in the borough of Darby on July 14, 1995. This single-end car, delivered on March 17, 1982, was 50 feet long, 8 feet 6 inches wide, and weighed 57,882 pounds. (Photograph by Kenneth C. Springirth.)

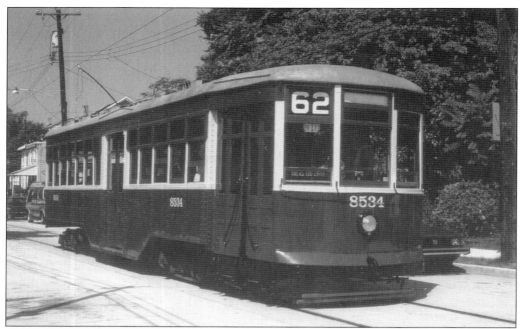

Peter Witt–style (named for the designer) car No. 8534 is on Ninth Street ready to turn onto Cedar Avenue in the borough of Darby on a rail excursion on July 6, 1997. This car was one of 50 single-ended cars ordered in 1926 from J. G. Brill Car Company. It has been preserved at the Electric City Trolley Museum. (Photograph by Kenneth C. Springirth.)

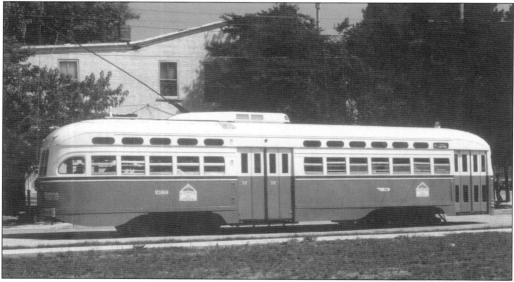

Presidents' Conference Committee car No. 2168 is on Ninth Street at Cedar Avenue in the borough of Darby on July 6, 1997. The Philadelphia Transportation Company received this car from St. Louis Car Company during July 1948. The Southeastern Pennsylvania Transportation Authority refurbished it during January 1986. It was a Chestnut Hill trolley from 1992 to 1996. The Baltimore Streetcar Museum purchased this car during 2005. (Photograph by Kenneth C. Springirth.)

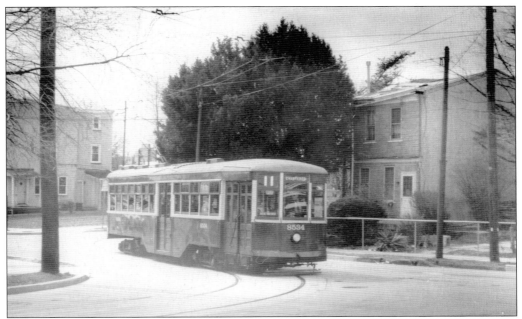

In this March 1999 scene, car No. 8534, originally built for the Philadelphia Rapid Transit Company, is at Ninth Street and Cedar Avenue in the borough of Darby on the former route 62. The Philadelphia Transportation Company ended the use of this series of cars in regular public transit service with the conversion of trolley route 17 to bus operation on December 29, 1957. (Photograph by Matthew W. Nawn.)

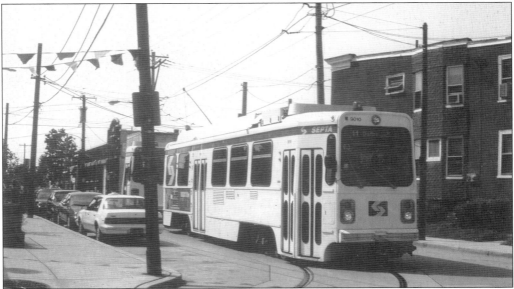

Southeastern Pennsylvania Transportation Authority car No. 9010 is on Cedar Avenue ready to make the turn onto Chester Avenue in the borough of Darby on an Electric Railroaders' Association excursion on July 4, 1999. Delivered on June 25, 1981, this single-end car, built by Kawasaki Heavy Industries, went into revenue service on August 3, 1981. (Photograph by Kenneth C. Springirth.)

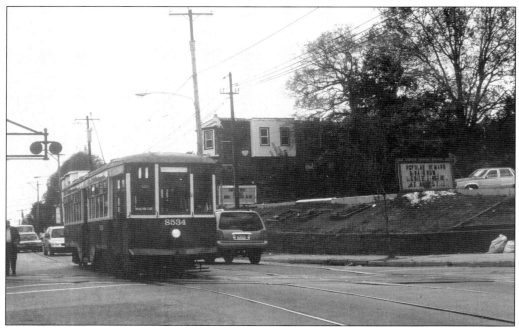

Car No. 8534 is on Main Street at the CSX Railroad crossing in the borough of Darby on November 5, 2000. This car was one of 50 single-ended cars ordered from J. G. Brill Car Company during 1926. It followed an order of 100 similar cars in 1924 and 385 similar cars in 1923. (Photograph by Kenneth C. Springirth.)

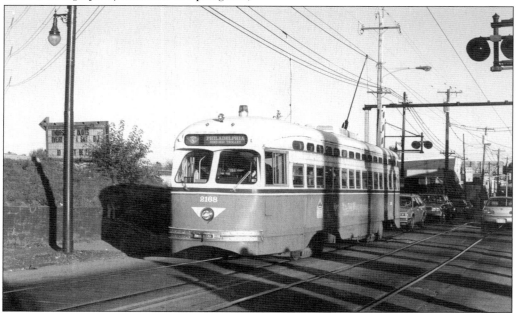

Presidents' Conference Committee car No. 2168 is westbound on Main Street just west of the CSX Railroad crossing. This car had been used on the Chestnut Hill trolley line, which ran over a portion of route 23 from Chestnut Hill Loop to the Germantown carbarn from 1992 to 1996 on Saturdays and Sundays but not holidays. (Photograph by Kenneth C. Springirth.).

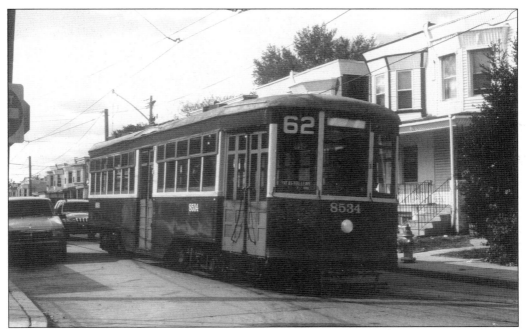

Car No. 8534 is on Ninth Street at Cedar Avenue in the borough of Darby on November 5, 2000. Beginning on June 1, 1907, route 13 (Chester Avenue Extension) operated over this trackage from Darby Loop to Sixty-fifth Street and Kingsessing Avenue. On November 10, 1916, route 62 operated over this trackage until January 23, 1971, when certain route 13 trolleys began using this trackage. (Photograph by Kenneth C. Springirth.)

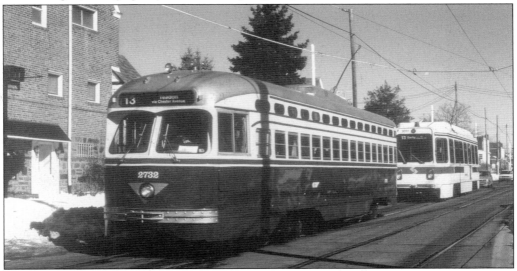

Presidents' Conference Committee car No. 2732, followed by Kawasaki Heavy Industries car No. 9081, is on Chester Avenue near Yeadon Loop on January 29, 2000. St. Louis Car Company delivered car No. 2732 to the Philadelphia Transportation Company during March 1947. The Southeastern Pennsylvania Transportation Authority refurbished this car during February 1985. In 2005, it was sold to Glen Echo Park near Washington, D.C. (Photograph by Kenneth C. Springirth.)

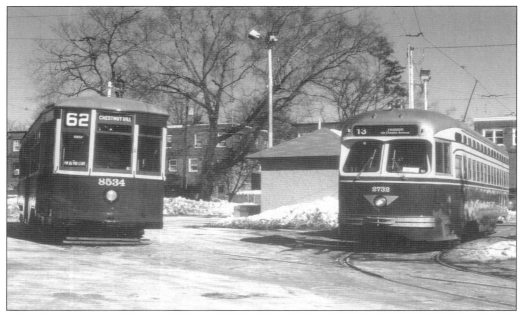

On January 29, 2000, car Nos. 8534 and 2732 are at Yeadon Loop. With the arrival of the Presidents' Conference Committee cars, many of the 8000 series cars, including No. 8534 (which has been preserved by the Electric City Trolley Museum at Scranton), were modernized with new gearing to reduce noise, leather upholstery over the wooden seats, and improved interior lighting. (Photograph by Kenneth C. Springirth.)

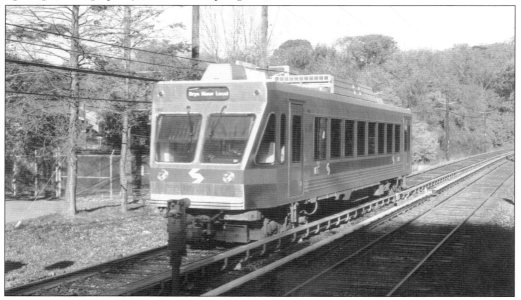

Route 100 Norristown High Speed Line type N5 car No. 146 is at West Overbrook station heading for the Sixty-ninth Street Terminal on October 29, 2001. This car was one of 26 cars numbered 130–155 built by Asea Brown Boveri during 1990 to 1994, with the first car No. 451 (later rebuilt as No. 130) tested at Amtrak's Beech Grove, Indiana, shops during October 1990. (Photograph by Kenneth C. Springirth.)

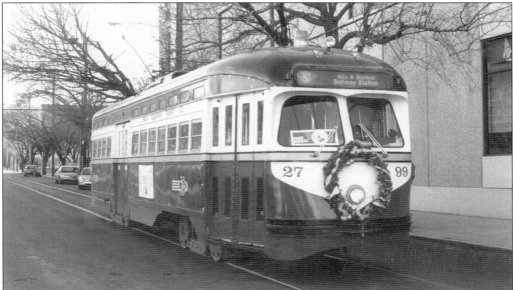

Festively decorated 1947 vintage Presidents' Conference Committee car No. 2799 is on Filbert Street at Fortieth Street on December 15, 2001, for the free Historic Holiday Trolley sponsored by the University City District, University of Pennsylvania, and the Southeastern Pennsylvania Transportation Authority. Trolleys operated Thursdays through Sundays from November 23 to December 24, 2001, from Fortieth and Market Streets to Forty-ninth Street and Chester Avenue. (Photograph by Kenneth C. Springirth.)

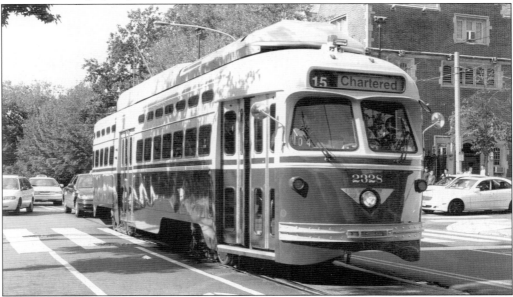

Car No. 2328 (original car No. 2726), completely rebuilt by Brookville Equipment Corporation, is eastbound on Spruce Street at Fortieth Street on October 16, 2004, providing a special free trolley service in the University City District. Established in 1997, the University City District has planned, promoted, and implemented improvements that have enhanced the quality of life in this 2.2-square-mile area of West Philadelphia. (Photograph by Kenneth C. Springirth.)

The oldest surviving Philadelphia trolley car, Southeastern Pennsylvania Transportation Authority "Tower Car" D-39, is near the Sixty-ninth Street Terminal on August 25, 1998. It was built in 1908 by the Philadelphia Rapid Transit Company as ash car No. 2621. This car was rebuilt several times and lasted in service until 2003. It is now preserved at the Rockhill Trolley Museum in the borough of Rockhill Furnace. (Photograph by Matthew W. Nawn.)

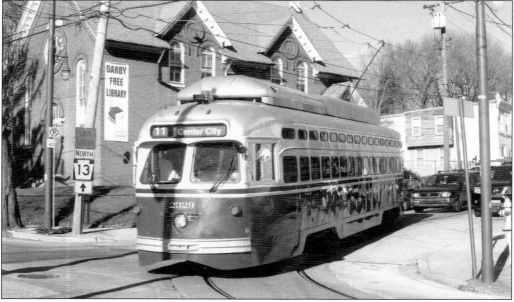

Passing the Darby Free Library, Southeastern Pennsylvania Transportation Authority rebuilt car No. 2329 (original car No. 2182) is on Tenth Street turning onto Main Street in the borough of Darby on February 3, 2007. The library is distinguished by the rose window in the front facade. Formed in 1743, the Darby Library was the first circulating library in Delaware County. (Photograph by Kenneth C. Springirth.)

Five

OCTOBER TROLLEY FEST

A celebration of transportation heritage and community was put together by the suburban communities of Darby, Yeadon, and Colwyn with southwest Philadelphia. On October 14, 2006, the second annual OC (October) Trolley Fest was held featuring free trolley car rides aboard two 1947 vintage completely rebuilt streamlined Presidents' Conference Committee trolleys, which traversed trackage of historical importance to the communities, plus it brought attention to the contribution of the trolley car in the growth of the area. Having set up a transit display at the event, the author saw firsthand the excellent cooperation between local governments, community organizations, businesses, and the transit authority. John and Jan Haigis, co-coordinators; Scott Maits, consultant and light-rail advocate; Sue Eshbach, Darby Free Library director of library services; Betty Schell, Darby Library history archives curator; William Neil, Yeadon Borough emergency management coordinator; Elizabeth Harris, assistant vice president of the Yeadon Office Sovereign Bank; and many others were involved with this event. When the route 11 trolley leaves the city limits at Cobbs Creek, the borough of Colwyn is on the south side of Main Street from Cobbs Creek to Fourth Street, and the borough of Darby is on the north side of Main Street. West of Fourth Street, both sides of Main Street are in the borough of Darby, which is used by route 11 to reach the Darby terminal. Trolley route 13 enters the borough of Yeadon after crossing Cobbs Creek and uses Chester Avenue to reach Yeadon Loop. Certain trips head west beyond Yeadon Loop and enter Darby at Cedar Avenue using North Tenth Street to reach the Darby terminal located on Main Street. The Darby terminal has been a transportation center providing connections between bus routes and the route 11 and 13 subway surface trolley lines to Center City Philadelphia. Darby (2000 census population of 10,299) was once a stopping-off point for travelers between Philadelphia and Baltimore. Colwyn (2000 census population of 2,453) is a station stop on the R2 Wilmington to Philadelphia regional rail line. Yeadon (2000 census population of 11,762) received its name from Yeadon Manor, the estate of William Bullock, who was born in Yeadon, England.

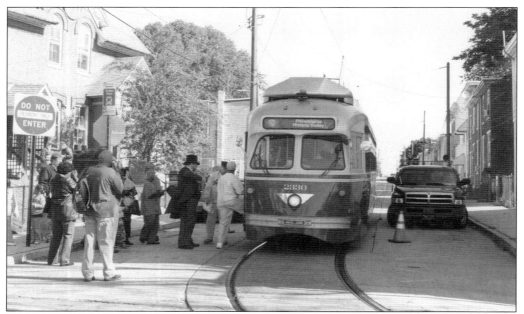

On October 14, 2006, car No. 2330 (original car No. 2730) is on Tenth Street at Main Street in the borough of Darby loading passengers for the OC Trolley Fest. This car was one of 18 cars that had been rebuilt by Brookville Equipment Corporation for route 15. It was delivered back to the Southeastern Pennsylvania Transportation Authority on July 14, 2004. (Photograph by Kenneth C. Springirth.)

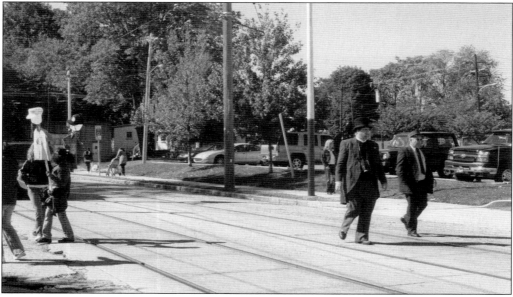

On Chester Avenue east of Cedar Avenue in the borough of Yeadon, John Haigis (OC Trolley Fest co-coordinator) with the large hat and Scott Maits (OC Trolley Fest consultant, light-rail advocate, historian, and tour guide) are leading the festivities with children holding scarecrows on the left on October 14, 2006. This was the second annual OC Trolley Fest to highlight community history and the trolley lines. (Photograph by Kenneth C. Springirth.)

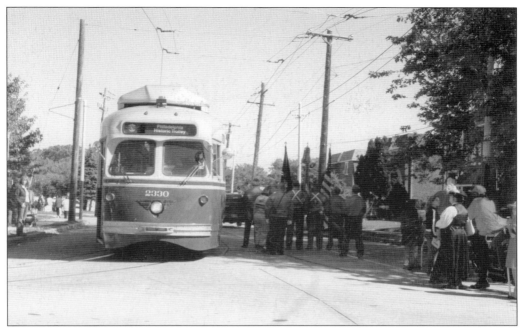

The OC Trolley Fest parade passes by trolley car No. 2330 (original car No. 2730) on Chester Avenue at Cedar Avenue on October 14, 2006. Free trolley rides were provided between Yeadon Loop via route 13 to Darby, and route 11 was used to reach Island Road where access trackage was used to loop at Elmwood Depot. (Photograph by Kenneth C. Springirth.)

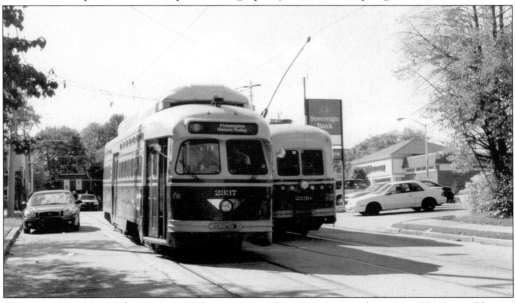

Car No. 2337 (original car No. 2783) passes car No. 2330 (original car No. 2730) on Chester Avenue east of Cedar Avenue on October 14, 2006. Brookville Equipment Company completely stripped and rebuilt each car with a new air-conditioning and heating system, wheelchair lift, propulsion and electrical systems, trucks and suspension, and a complete remanufacturing of remaining parts. (Photograph by Kenneth C. Springirth.)

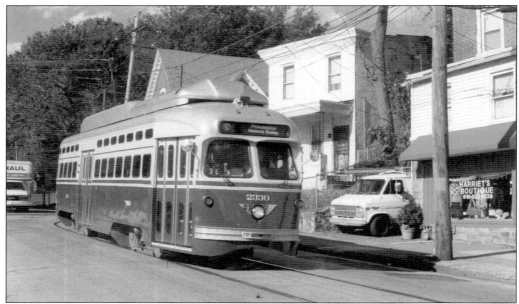

Car No. 2330 has turned from Tenth Street onto Main Street in the borough of Darby on October 14, 2006, for the OC Trolley Fest. The Southeastern Pennsylvania Transportation Authority conducted a trolley fest during October 2–3, 1993, using two vintage trolleys and conducted another trolley fest on October 21–22, 1995, that operated a variety of trips in Philadelphia. (Photograph by Kenneth C. Springirth.)

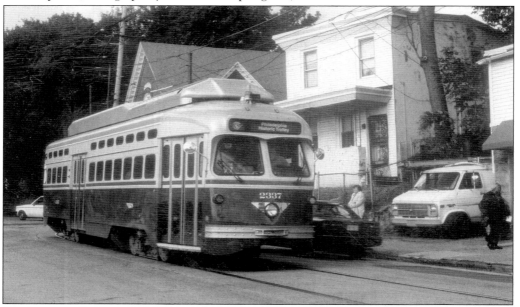

Southeastern Pennsylvania Transportation Authority car No. 2337 is on Main Street south of Tenth Street in the borough of Darby on October 14, 2006. This is close to the Darby Transportation Center where there is a former trolley bridge that was constructed over Darby Creek in 1904. The bridge consists of a single-span Warren-type truss structure with an elevated deck through the trusses. (Photograph by Kenneth C. Springirth.)

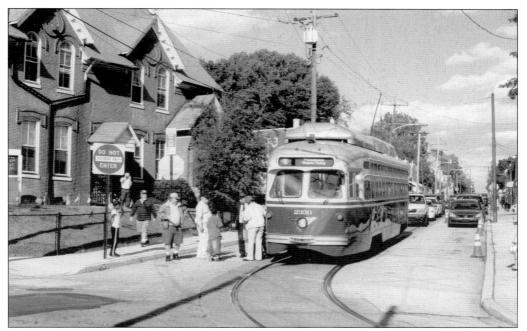

Southeastern Pennsylvania Transportation Authority car No. 2330 is unloading passengers on Tenth Street at Main Street at the Darby Free Library on October 14, 2006, for the OC Trolley Fest. Sue Eshbach, director of library services, set up various displays at the library, and Betty Schell, history archives curator, prepared a transportation history board. (Photograph by Kenneth C. Springirth.)

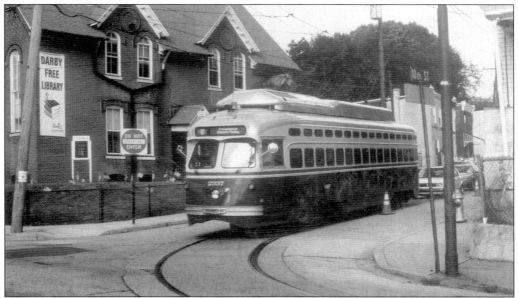

The Darby Free Library has a treasury of history information conveniently located on the OC Trolley Fest trolley tour with Southeastern Pennsylvania Transportation Authority car No. 2337 passing by Tenth Street at Main Street on October 14, 2006. The borough of Darby was once an exclusive suburb for Philadelphia merchants. (Photograph by Kenneth C. Springirth.)

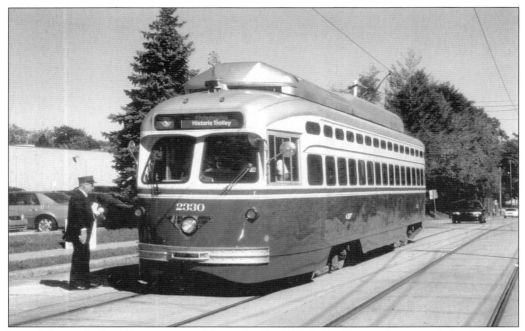

Scott Maits, who handles a variety of duties for the OC Trolley Fest, is shown with Southeastern Pennsylvania Transportation Authority car No. 2330 on Chester Avenue at Yeadon Plaza on October 14, 2006. Trolley car service from Yeadon to Darby began on June 1, 1907, by the route 13 Chester Avenue Extension. (Photograph by Kenneth C. Springirth.)

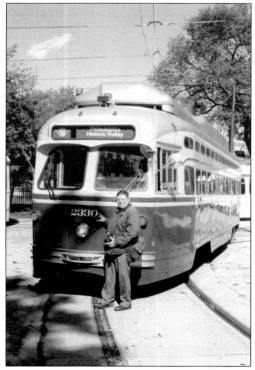

Kenneth C. Springirth, the author of this book, is shown with Southeastern Pennsylvania Transportation Authority car No. 2330 at Yeadon Loop for the OC Trolley Fest on October 14, 2006. Most route 13 cars from Center City Philadelphia terminate at Yeadon Loop with certain trips operating west to the Darby Transportation Center.

Darby Transportation Center features a mural commemorating the start of horse-drawn streetcar service to Darby on December 24, 1858, by Colwyn artist Tom Manczur. The mural was dedicated on September 29, 2006. OC Trolley Fest 2006 had free trolley car rides, a parade, and a marker dedication to the 1925 Negro Baseball League world champion Hilldales at Yeadon Plaza. (Photograph by Kenneth C. Springirth.)

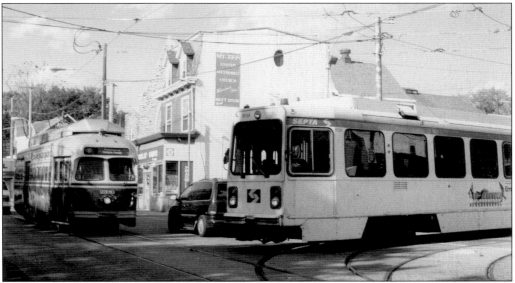

Southeastern Pennsylvania Transportation Authority–rebuilt car No. 2330 waits for route 11 car No. 9039 to pull out of the Darby Transportation Center for the eastbound trip to Center City Philadelphia on October 14, 2006. The OC Trolley Fest was a celebration of transportation heritage and looking at existing community assets for meeting future needs. (Photograph by Kenneth C. Springirth.)

ACROSS AMERICA, PEOPLE ARE DISCOVERING SOMETHING WONDERFUL. *THEIR HERITAGE.*

Arcadia Publishing is the leading local history publisher in the United States. With more than 3,000 titles in print and hundreds of new titles released every year, Arcadia has extensive specialized experience chronicling the history of communities and celebrating America's hidden stories, bringing to life the people, places, and events from the past. To discover the history of other communities across the nation, please visit:

www.arcadiapublishing.com

Customized search tools allow you to find regional history books about the town where you grew up, the cities where your friends and family live, the town where your parents met, or even that retirement spot you've been dreaming about.